Going-to-the-Sun Road

Glacier National Park's Highway to the Sky

by C. W. Guthrie

**Glacier
Natural
History
Association**

FARCOUNTRY
PRESS

Helena, Montana

ACKNOWLEDGMENTS

This history of the planning and construction of the Going-to-the-Sun Road is but a brief glimpse at the work of the many engineers and laborers who toiled to build it. All of us who drive the Sun Road are indebted to them.

In my attempt in these pages to characterize the thinking of the times, the work, and the men who built the road, I was privileged to use the construction reports of the Bureau of Public Roads project engineers, the excellent research contained in Mark Hufstetler's comprehensive Cultural Landscape Report, and the nomination pages for the National Civil Engineering Landmark Program run by the American Society of Civil Engineers.

Ann Fagre, the Glacier Natural History Association museum technician for the Glacier National Park archives, provided immeasurable help in locating documents and providing historical photographs. Thank you, Ann. I am truly grateful.

Thanks are also due to Glacier National Park's Lon Johnson, Jack Gordon, Dave Dahlen, Jim Foster, and Magi Malone, who were great sources of information; and to Robert Smith of UpperWest Creative Services for allowing me to use his Glacier National Park postcard collection.

As always, I enjoyed working with Wendy Hill and Stephen Prince of the Glacier Natural History Association, and the fine staff at Farcountry Press: Kathy Springmeyer, Jessica Solberg, Caroline Patterson, and Shirley Machonis. Thank you.

ISBN 10: 1-56037-335-0
ISBN 13: 978-1-56037-335-3
© 2006 Farcountry Press
Text © 2006 C. W. Guthrie

Front cover photograph © Chuck Haney.

The trademarks and logo images of the Great Northern Railway appearing in this book are owned by BNSF Railway Company and may not be reproduced or used without the permission of BNSF Railway Company.

For more information about our books write Farcountry Press, P.O. Box 5630, Helena, MT 59604; call (800) 821-3874; or visit www.farcountrypress.com.

Library of Congress Cataloging-in-Publication Data

Guthrie, C. W.
 Going to the sun road : Glacier National Park's highway to the sky / by Carol Guthrie.
 p. cm.
 ISBN-13: 978-1-56037-335-3
 ISBN-10: 1-56037-335-0
 1. Automobile travel—Montana—Going-to-the-Sun Road—History. 2. Automobile travel—Montana—Glacier National Park—History. 3. Going-to-the-Sun Road (Mont.)—Description and travel. 4. Glacier National Park (Mont.)—Description and travel. 5. Glacier National Park (Mont.)—History, Local. I. Title.
 F737.G5G89 2006
 978.6'52—dc22

 2005028103

Created, produced, and designed in the United States.
Printed in China.

17 16 15 14 13 3 4 5 6 7

TABLE OF CONTENTS

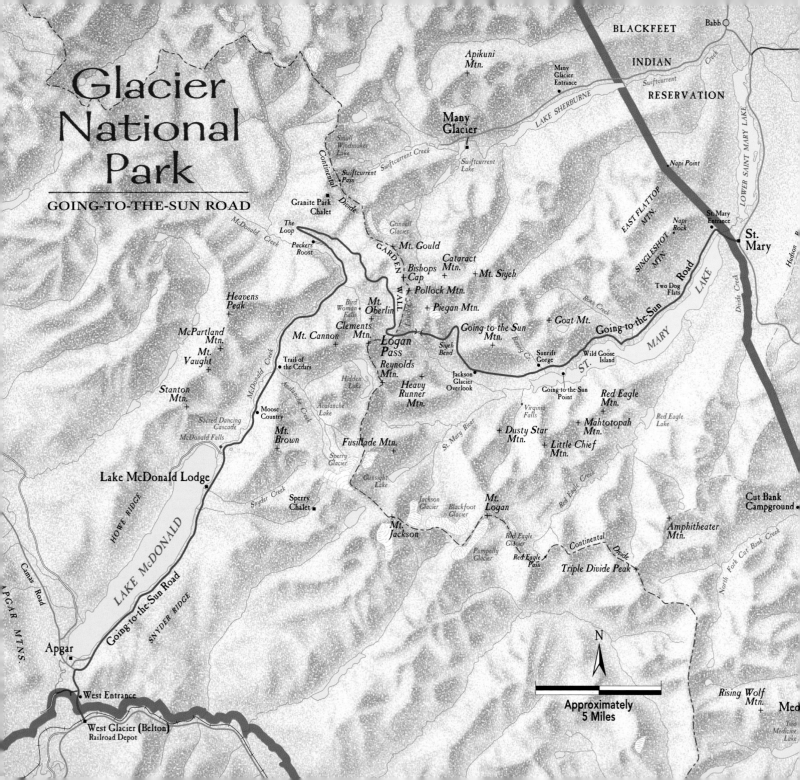

Glacier National Park

GOING-TO-THE-SUN ROAD

BLACKFEET

Babb

INDIAN

Apikuni Mtn.

Many Glacier Entrance

RESERVATION

Swiftcurrent Creek

Napi Point

LAKE SHERBURNE

Small Windmaker Lake

Many Glacier

Swiftcurrent Lake

LOWER SAINT MARY LAKE

Continental Divide

Swiftcurrent Pass

Grinnell Glacier

St. Mary Entrance

St. Mary

Granite Park Chalet

EAST FLATTOP MTN.

Napi Rock

SINGLESHOT MTN.

Hudson R.

McDonald Creek

The Loop

Packers Roost

GARDEN WALL

Mt. Gould

Bishops Cap

Cataract Mtn.

Mt. Siyeh

Two Dog Flats

Going-to-the-Sun Road

Heavens Peak

Bird Woman Falls

Mt. Oberlin

Pollock Mtn.

Piegan Mtn.

Rose Creek

ST. MARY LAKE

McPartland Mtn.

Mt. Vaught

Clements Mtn.

Mt. Cannon

Logan Pass

Going-to-the-Sun Mtn.

Goat Mt.

Going-to-the-Sun

Divide Creek

Trail of the Cedars

Reynolds Mtn.

Siyeh Bend

Sunrift Gorge

Wild Goose Island

Stanton Mtn.

McDonald Creek

Hidden Lake

Heavy Runner Mtn.

Jackson Glacier Overlook

Going-to-the-Sun Point

Red Eagle Mtn.

Red Eagle Lake

Sacred Dancing Cascade

Moose Country

Avalanche Creek

Avalanche Lake

Virginia Falls

St. Mary River

Mahtotopah Mtn.

McDonald Falls

Mt. Brown

Fusillade Mtn.

Dusty Star Mtn.

Little Chief Mtn.

Lake McDonald Lodge

Sperry Glacier

Red Eagle Creek

Cut Bank Campground

HOWE RIDGE

Snyder Creek

Sperry Chalet

Gunsight Lake

Jackson Glacier

Blackfoot Glacier

Mt. Logan

Red Eagle Glacier

Amphitheater Mtn.

LAKE McDONALD

SNYDER RIDGE

Going-to-the-Sun Road

Mt. Jackson

Pumpelly Glacier

Red Eagle Pass

Continental Divide

North Fork Cut Bank Creek

APGAR MTNS.

Camas Road

Triple Divide Peak

Apgar

West Entrance

N

Rising Wolf Mtn.

Med

West Glacier (Belton) Railroad Depot

Approximately 5 Miles

Two Medicine Lake

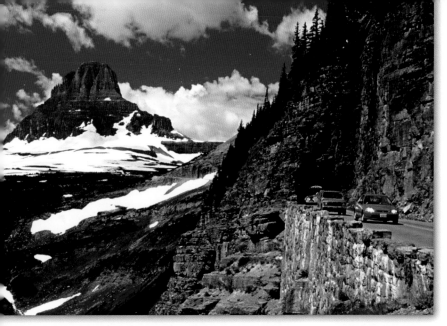

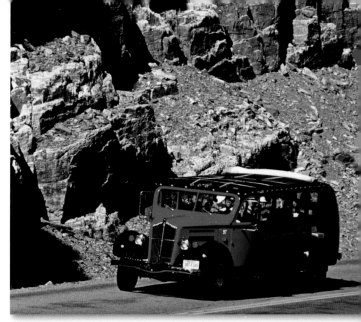

PHOTOS CLOCKWISE: *The East Side Tunnel on the Going-to-the-Sun Road, with Clements Mountain in the background.* PHOTO BY JOHN REDDY.
A popular red "jammer bus" ascends the Going-to-the-Sun Road near Logan Pass. PHOTO BY CHUCK HANEY.
Much of the narrow road has been carved into the solid rock. PHOTO BY CHUCK HANEY.
Golden aspens and cottonwoods frame this view of the Garden Wall from the Going-to-the-Sun Road. PHOTO BY CHUCK HANEY.

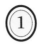

Going-to-the-Sun Road:
A Marvel Traversing an Even Greater Marvel

"A national park highway should have not only fine natural scenery, but exhibitions of ingenious engineering skill. It should have at least a few tunnels, galleries, terraces, bridges, hairpin turns, and all that sort of thing—to produce the surprises, thrills and joys that tourists seek."
—Professor Lyman Sperry, explorer.
From a 1915 letter to the Kalispell Chamber of Commerce, published in the *Kalispell Bee*

A tourist feeds a marmot against a backdrop of the Weeping Wall, a Going-to-the-Sun-Road landmark. Feeding or approaching any wildlife in the park is dangerous and prohibited today. COURTESY OF THE ROBERT SMITH COLLECTION.

Driving the Going-to-the-Sun Road is, according to many an author and millions of tourists, a jaw-dropping, heart-pounding, simply magnificent, and totally unforgettable experience. That this road exists and somehow seems to belong in this rugged, wild country is a marvel of engineering and gritty determination to do it right.

Park officials, landscape architects, construction engineers, and countless hard-working men labored nearly 20 years to carve a road that blends in with Glacier's magnificent landscape—its towering mountains, hauntingly beautiful valleys, clear, cold mountain lakes, and roiling, rushing streams. Along the alpine heights, where the icy glint of snow pinnacles the peaks and in their

laps a few receding glaciers shine their long farewell, crews of robust men benched a road on the edge of perilous 1,000-foot drop-offs to take us across the mountains and give us a bird's-eye view of the most stunning scenery in America.

Dedicated in 1933, the Going-to-the-Sun Road, or the Sun Road as it is sometimes known, was the first national park road designed to complement the scenic wonders it traversed. It was finely crafted over a tortuous, some thought impossible, route—one that was more costly than the other routes that were proposed. It was built to the highest standards of road construction of the times, with the least damage to the country it traversed, which had never been done before on so large a scale. Designed to harmonize with the landscape in such a way as to be almost unseen, it is one of the most scenic highways in the world.

Fifty Miles of History

Road length: 50 miles from West Glacier to St. Mary

Road width: 22 feet, except for 10 miles along the Garden Wall, which are narrower

Road's highest elevation: 6,646 feet at Logan Pass

Road grade: Maximum six percent from The Loop along the Garden Wall to Logan Pass

CONSTRUCTION DATES:

West of the Continental Divide:

1911–1921 Belton (West Glacier) to the foot of Lake McDonald

1921–1922 Foot of Lake McDonald to the head of Lake McDonald

1922–1923 Head of Lake McDonald to Avalanche Creek

1924–1925 Avalanche Creek to Logan Creek

1925–1928 Logan Creek to Logan Pass

East of the Continental Divide:

1922–1925 St. Mary to Rising Sun

1931–1932 Logan Pass to Rising Sun

1933–1934 Rising Sun to St. Mary realigned and widened

Construction costs up to 1934: $2.4 million

Period of road reconstruction and improvement: 1933–1955

SIGNIFICANT FEATURES:

The Loop and Siyeh Bend

The 192-foot West Side Tunnel and the 408-foot East Side Tunnel

The Crystal Point half-tunnel

The eight bridges at Belton, Snyder Creek, Avalanche Creek, Logan Creek, Haystack Creek, Baring Creek, St. Mary River, and Divide Creek

The 30,000 linear feet of pipe and boxed drainage culverts faced with native stone. The most visible and historically significant culverts are at Sprague Creek, Granite Creek, Haystack Creek, and Siyeh Creek.

The retaining walls of native stone, most notably the Triple Arches along the Garden Wall and the Golden Stairs along St. Mary Lake

Horse trail underpasses near McDonald Falls and Jackson Glacier Overlook

The 40,000 feet of historic native stone guard walls

The Going-to-the-Sun Road set the standard for all national parks. It is the best of its kind and one of America's most treasured cultural resources. It was the first road to be designated as a National Historic Landmark and is the only road to date that is designated both a National Historic Landmark and a National Civil Engineering Landmark. The road is also on the National Register of Historic Places.

This road of roads not only provides the opportunity for millions of travelers from the United States and around the world to enjoy the scenic wonders of Glacier National Park, it is a testament to our will and ability to build in harmony with nature, and place preservation ideals over other considerations. The result, to paraphrase Michael Jamison, reporter for the *Missoulian* newspaper, is a marvel traversing an even greater marvel.

Legends to Name a Road By

The road across the Rocky Mountains through the heart of Glacier National Park was first known as the Transmountain Highway, then the Transmountain Road. Although this name describes the road's route, it does not do it justice. Park naturalist George C. Ruhle and Montana congressman Louis C. Cramton have both been credited with suggesting the road be named after Going-to-the-Sun Mountain. J. Ross Eakin, who was Glacier National Park superintendent from 1927 to 1931, liked the idea, and the name of the Transmountain Road was officially changed to Going-to-the-Sun Road. Eakin said the new name "gives the impression that in driving this road autoists will ascend to extreme heights and view sublime panoramas."

There are at least two tales of how Going-to-the-Sun Mountain was named. In the stories of the Blackfeet tribe, the Going-to-the-Sun Mountain has been known as Lone High Mountain, To-the-Sun-He-Goes Mountain, and The-Face-of-Sour-Spirit-Who-Went-Back-to-the-Sun-After-His-Work-Was-Done Mountain. In their ancient stories, the trickster figure of Napi (who was also known as Old Man, or Sour Spirit) is the son of the Sun and the Moon. He comes to earth to save his people in a time of trouble and, when his work is done, he returns to his home in the sky by climbing up the mountain to the sun.

Glacier explorer and author James Willard Schultz claims he named the mountain. Sometime in the 1880s, he and his Blackfeet guide Tail-Feathers-Coming-In-Sight-Over-the-Hill were seated around a campfire. During their travels together, Tail Feathers had told Schultz of the ancient Blackfeet tales of Napi returning to the Sun and stories about young men who go to the highest mountains to be as close to the Sun and the Moon as they can, in search of their vision. He pointed to the lone, high mountain and said it would be a good place for a vision quest. Both Schultz and Tail Feathers agreed Going-to-the-Sun would be a good name for the mountain.

ILLUSTRATION BY DIANA KRAGE.

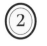

OVER THE RIVER AND THROUGH THE WOODS

Quagmire and Corduroy

In the nineteenth century, when the cities in the east and coastal west were bustling with trolleys and bicycles and the smoke and backfire of the new motorized vehicles, the Glacier area and the inland northwest were just being settled.

The completion of the Great Northern Railway in 1893 brought a surge of settlement to the northwest. Rail service from the east along the southern border of what was to become Glacier National Park and as far west as Columbia Falls in the Flathead Valley was available in 1891. By 1892, the Flathead Valley boasted substantial settlement and agricultural development, and the first permanent settlers had homesteaded in the Glacier area.

About this same time, the spectacular scenery of the mountains was being lauded in Great Northern Railway advertising brochures throughout the east. A trickle of tourists began coming to Glacier to enjoy this new wilderness playground. At the same time, the town of Belton, now known as West Glacier, began to grow up around the two boxcars that served as the Great Northern Railway's depot on the park's western border. Its few residents began building hotels and diners to accommodate the tourists stopping at the Belton Station.

Across the Middle Fork of the Flathead River, and about three miles north of Belton, Glacier's new perma-

This 1920s photo shows the bridge across the Middle Fork of the Flathead River before it was destroyed in the 1964 flood. A new bridge is located downstream. R. E. MARBLE, PHOTOGRAPHER. COURTESY OF GLACIER NATIONAL PARK ARCHIVES.

A Nation in Motion

Americans' need to travel to new places or experience some distant wonder of the landscape was apparent long before covered wagons slowly creaked over the trails blazed by explorers Meriwether Lewis and William Clark and mountain man Jim Bridger. And with each new discovery of place, new ways to travel were born.

1769–1830s—French engineer Nicolas Joseph Cugnot invents the first self-propelled steam-powered road vehicle in 1769—a French military tractor. European and American inventors continue to tinker with steam- and electric-powered engines.

1869—The first U.S. transcontinental railroad replaces stagecoaches and covered wagons as the primary means of overland travel.

1876—European Nicolaus Otto invents the gas motor engine.

1880s and Gay Nineties—Short-run railroad lines, trolleys, and bicycles replace buggies, buckboards, and wagons in the cities.

1885—Karl Benz builds the world's first internal-combustion-engine-powered automobile.

1891—John Lambert invents America's first gasoline-powered automobile.

1893—The Department of Agriculture establishes the Office of Road Inquiry to promote rural road development for wagons, coaches, and bicycles.

Bicycle mechanics Charles and Frank Duryea found America's first gas-powered automobile company.

1899—There are 30 automobile manufacturers in America and 8,000 automobiles on the road.

1903—Henry Ford forms the Ford Motor Company and transforms assembly-line manufacturing, making cars faster and cheaper to build.

1905—The Office of Road Inquiry becomes the Office of Public Roads, with added responsibilities.

1908—Ford introduces the "motorcar for the multitudes," the low-priced Model T that sold for less than a wagon and team. Known as the Tin Lizzie, Flivver, or T, it launched the era of the automobile in America.

1910—Half a million automobiles travel over U.S. roads.

1916—Congress passes the Federal Aid to Highways Act to improve and create passable roads.

1919—The Office of Public Roads becomes the Bureau of Public Roads.

1921—Congress passes the Federal Highway Act to provide two-lane interstate highways.

By the close of the 1920s, 27 million vehicles rolled 198 billion miles over about 830,000 miles of paved U.S. roads.

nent homesteaders Milo Apgar, Charlie Howe, and Frank Geduhn established a settlement, which would later become known as Apgar, at the foot of Lake McDonald. These homesteaders recognized the opportunity to make money from the new tourist trade. They built cabins on the shores of Lake McDonald and began providing meals and accommodations for tourists. The word got around, and the trickle of visitors arriving on the trains at Belton began to slowly grow into a steady stream.

In order to take the tourists from the railroad station to Apgar, at the foot of Lake McDonald, the entrepreneurial residents of Belton and Apgar carved the first real wagon road in the Glacier area in 1893. Using saws, picks, and shovels they cleared a crude path, wide enough for a wagon or stage, through the forest of western red cedar from the river to Apgar.

Tourists visiting Glacier rode the Great Northern train to Belton, got in a buckboard, or walked about a quarter of a mile to the banks of the Middle Fork of the Flathead River. They crossed the river in rowboats, then boarded a Concord coach pulled by a team of horses and bounced along the three miles of tree-lined, rough-cut road to Apgar to enjoy the scenic splendors of Lake McDonald. They must have enjoyed the

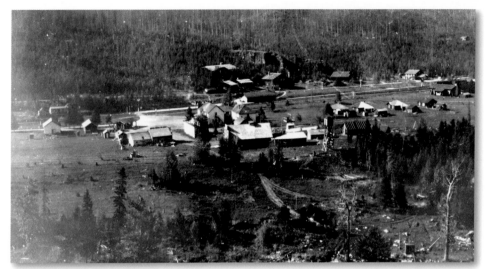

Belton, Montana, (currently West Glacier) in June 1929. COURTESY OF GLACIER NATIONAL PARK ARCHIVES.

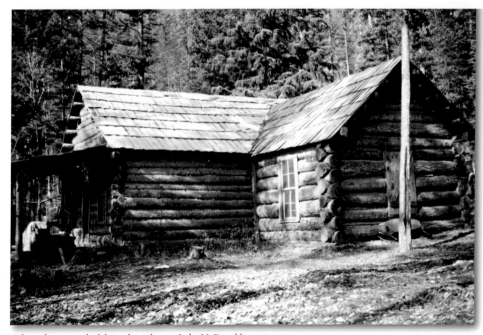

A log cabin, typical of the early settlers, at Lake McDonald. COURTESY OF GLACIER NATIONAL PARK ARCHIVES.

whole adventure. Many returned often to see the glaciated mountains and valleys, as well as the crystal-clear lakes, and Glacier grew more and more popular as a tourist destination.

Encouraged by the increase in tourism and the resulting prosperity in Apgar and Belton, George Snyder built a nine-room hotel near the head of Lake McDonald in 1895. He bought a steamboat to take the tourists the 13 miles across the lake from Apgar to his hotel at the head of the lake. In order to haul the newly purchased steamboat to Lake McDonald, Snyder and the Belton and Apgar residents widened and corduroyed (laid logs side by side to create a road surface) some sections of the three-mile road from the river to Apgar.

Even with the improvements that were made to haul Snyder's steamboat to the lake, the road to Apgar was described by a reporter for a Kalispell newspaper as "a combination of quagmire, corduroy, and misery, the worst and most objurgated three miles in the state of Montana, dreaded by those who had ridden over it, feared by those who expected to, fitted to take the blue ribbon at an exhibition of horrible examples."

Apgar and Belton residents continued to row boatloads of anxious tourists across the sometimes roiling river that separated the two towns for another two years. In 1897, they built a log bridge across the Middle Fork of the Flathead River so they could offer stage transportation from one town to the other. The National Park Service replaced the old log bridge with a concrete arch bridge in 1920; it was located upstream of the current bridge.

Rails, Trails, and a Road

When Glacier was established as a national park in 1910, Belton had grown into a notable little town, with several residences, hotels, and stores. The two boxcars previously used as a depot were replaced around 1906 by an impressive Great Northern train station built in rustic bungalow-style architecture. Nearby, Belton Chalet, the first of many Great Northern Swiss-style chalets to be built in or near Glacier National Park, was almost completed.

The little village of Apgar also prospered in the wake of increased interest in Glacier National Park. Several residences, tourist cottages, camping supply storehouses, and sheds to store hay for the stagecoach horses were nestled in the woods. A large pier was built on the shore of Lake McDonald to board tourists onto Snyder's steamboat that, seasonally, was steaming up and down the lake several times a day. The pier was also used by smaller gas-powered boats that took tourists around the sapphire-blue waters of the lake.

At the head of Lake McDonald, John Lewis had purchased Snyder's hotel and built 11 guest cabins. In 1913, he moved Snyder's Hotel a short distance away and turned it into a general store. On the old hotel site he built the new Glacier Hotel, copying the Swiss-style architecture of the Great

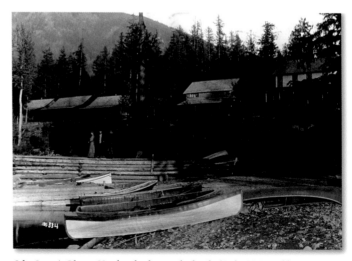

John Lewis's Glacier Hotel and cabins at the head of Lake McDonald.
COURTESY OF GLACIER NATIONAL PARK ARCHIVES.

Northern buildings in the park. Lewis's guests arrived by steamboat and then walked up to the hotel from the dock. The Lewis Hotel was sold to the Great Northern Railway in 1930 and was renamed Lake McDonald Lodge.

Although the newly established Glacier National Park was becoming ever more popular as a tourist destination, and Belton and Apgar were steadily growing, access to the park from the surrounding communities was limited. On the western border, the nearest road to Glacier from the growing communities of the Flathead Valley ended eight miles away at Coram.

There was, however, an unpaved, nearly impassable tote road from Belton to Coram that the railroad had built during the construction of the Great Northern Railway line. On May 2, 1911, Kalispell resident Frank Stoop set out to prove the old tote road was passable by automobile. He left Coram in his E.M.F. "30" motorcar and arrived nine exhausting hours later in Belton. The first automobile had arrived in Glacier, a harbinger of what was to come.

While Frank Stoop was putt-putt-putting along in his motorcar toward Glacier, the Flathead County commissioners and the Flathead County Auto Club were busy arranging to build an

The new Going-to-the-Sun Highway over Logan Pass in Glacier National Park. Travelers on the "Empire Builder" now can make this thrilling motor detour on a one-day stopover.

COURTESY OF THE ROBERT SMITH COLLECTION AND BURLINGTON NORTHERN SANTA FE RAILWAY.

automobile road from Coram that would connect with the Belton-to-Apgar road into the park. By the end of the summer, the eight-mile road to Belton was complete, and the western side of Glacier was linked to its neighboring communities. Motorists could drive to the park borders, but soon that would not be enough. Motoring clubs and local, state, and national agencies began lobbying for automobile roads *inside* the park.

The official policy of the Department of the Interior was to ban cars from reserves and national parks to protect the natural surroundings. However, overwhelming pressure from a rapidly increasing number of motorists forced the department to yield, and it reluctantly admitted automobiles into most of the parks in 1907. In Yellowstone, the automobile was banned until 1915 to avoid conflicts with horses; in Glacier there were no accessible roads until 1912.

Connecting East to West

The demand for roads in Glacier National Park was no surprise to park

13

officials, who recognized the lack of roads in the park and its inaccessibility to surrounding communities as a major problem in Glacier's development as a national park. Various officials were proposing and planning roads in the park almost before the ink was dry on President William Taft's May 11, 1910, signature designating the area as Glacier National Park. The chief topographer of the U.S. Geo-graphical Survey, Bob Marshall (in whose memory the Bob Marshall Wilderness is named), recommended a 213-mile system of roads to all the scenic points in Glacier, and a trans-mountain road from Belton to Waterton Lakes in Canada. William Logan, Glacier's first superintendent, and his successors all pressed for a road across the Continental Divide to connect the east and west sides of the park. During Glacier's first year as a national park, officials even brought in engineers and road specialists to evaluate proposed routes. At that time, national parks came under the Department of the Interior; however, most of the parks were managed by the U.S. Army and had to compete with other requirements of both agencies for funds. There was an overall critical shortage of government funds and none of these early proposals would be funded or constructed.

Although there were no roads crossing the Continental Divide and linking the eastern and western sides of Glacier National Park, there were trails across the Continental Divide. In the early 1900s, Professor Lyman Sperry and a group of students sponsored by the Great Northern Railway built a trail over Gunsight Pass. Later another trail was built over Swiftcurrent Pass. Rangers and tourists traveled to the eastern and western sides of the park on foot or horseback across these two trails. More often, however, they boarded a Great Northern train at the Midvale Station on the park's east side or the Belton Station on the west side to travel back and forth.

When Congress passed legislation to make Glacier a national park, they provided very little funding to develop

Maj. William R. Logan, Glacier National Park's first superintendent.
COURTESY OF NATIONAL PARK SERVICE, HARPERS FERRY CENTER.

visitor facilities or protect the natural resources. Fortunately for park visitors, the Great Northern Railway considered Glacier National Park a premier tourist destination for their line. They created a world-wide advertising program proclaiming Glacier's scenic wonders as America's Swiss Alps. The railroad established the Glacier Park Hotel Company to build Swiss-style hotels, tepee campsites, and other tourist facilities throughout the park.

The Great Northern Railway designed and built most of the early trails and wagon roads in the park to take tourists to scenic points and to connect the growing number of facilities they were building. In 1912, the railroad constructed a 4.8-mile spur road from the village of St. Mary on the park's eastern border to Roes Creek inside the park. Later, this spur road was realigned as part of the Going-to-the-Sun Road.

During the same year, the railroad also constructed a rough 34-mile dirt road that ran through the Blackfeet Indian Reservation. This road, which later became part of the Blackfeet Highway, connected the Great Northern Railway station at Midvale (East Glacier) to the spur road into the park and to their tourist facilities at Swiftcurrent. The National Park

Service later reimbursed the railroad for the construction of the St. Mary spur into the park, and the government eventually rebuilt the road from East Glacier to St. Mary.

Although the Great Northern Railway built most of the roads in the park, the railroad had no interest in promoting the construction of an east-to-west transmountain road across the heart of Glacier for automobiles. Such a road would directly compete with the railroad. When motoring tourists came to the park's boundaries, they paid the Great Northern Railway $15 to haul their vehicles from one side of the park to the other, and they toured inside the park in Great Northern wagons and stages. However, once the Going-to-the-Sun Road was opened, the railroad extolled the scenic wonders along the road in their postcards and advertising brochures and provided car-bus tours over the road for its lodge and hotel guests.

Logan's Road

Anyone who drives through Glacier National Park will recognize the name Logan. The highest point on the Going-to-the-Sun Road is named Logan Pass, and Trapper Creek was renamed Logan Creek (Trapper Creek Trail retains its

name). These landmarks are named for the park's first superintendent, Maj. William R. Logan. Before being assigned to Glacier, Logan had been superintendent of the Indian Training School at Fort Belknap, Montana, and supervisor of industries at large for the Indian Service. In the early 1880s, he accompanied geologist Raphael Pumpelly through Glacier as a packer and scout. He became familiar with the mountains and valleys and was considered somewhat of an authority on Glacier country. Logan was assigned to the park in August 1910 and was given the title of superintendent of road and trail construction. In December he was appointed inspector in charge, and by April 1911, his position as Glacier National Park superintendent was officially established.

Logan's park headquarters in 1910 consisted of tents in Apgar until he rented a cabin in 1911. One of Logan's tasks was constructing the first permanent park headquarters and housing for park rangers, along with extending a telephone line to the park headquarters. He set about accomplishing these tasks, while promoting the notion that "a road from some one of the mountain passes from the east to the west side" was a necessary expenditure for the park's development.

Old road along the Middle Fork of the Flathead River between Glacier National Park headquarters and Belton, 1925.
COURTESY OF GLACIER NATIONAL PARK ARCHIVES.

Clearing for the "new government road" at the foot of Lake McDonald. COURTESY OF GLACIER NATIONAL PARK ARCHIVES.

In 1911, while Frank Stoop was driving the first auto to Glacier over a tote road and the citizens of the Flathead Valley were busy building a road from Coram to the park border, Logan began constructing a "new government road" from Belton to the foot of Lake McDonald. Known as the Apgar Road, this short segment of government road was the first federal construction on what would later become the Going-to-the-Sun Road.

Logan would never know that this two-and-one-half-mile road was the start of his much-sought-after road across the mountains, which would someday carry millions of travelers through the heart of Glacier National Park. He died in February 1912 while on a trip to the east.

The Apgar Road was finished the following year. The road was 24 feet wide with 8-foot-wide shoulders and surfaced with finely crushed gravel. It was no longer the "quagmire, corduroy, and misery" of the past. Instead, it was described in local newspapers as a boulevard or a speedway. It was, indeed, a road built for automobiles, and the beginning of the Transmountain Highway across Glacier National Park, which we now know as the Going-to-the-Sun Road.

LYING LIGHTLY ON THE LAND

The fate of the Transmountain Highway was decided on a mountaintop in 1924, when Thomas Vint, a wet-behind-the-ears landscape architect, bravely stepped forward to oppose veteran road-building engineer George E. Goodwin's plan to build a road that rose to the summit of Logan Pass in Glacier National Park in a series of 15 switchbacks. Vint said it would "look like miners had been in there." Then he turned to Stephen Mather, the director of the National Park Service (NPS), and proposed a longer road that rose along the face of the Garden Wall in a single switchback. This moment was the beginning of the Going-to-the-Sun Road as we know it today.

It had only been eight years since the NPS was created in 1916 under the Department of the Interior. The NPS was given the weighty task of preserving the results of billions of years of nature's finest work, the remnants of human history, and the existing wildlife species in the parks, while making

these wonders pleasurably accessible to the public. The decision on where to locate the Transmountain Highway and to ensure it did not permanently scar the scenic heart of Glacier National Park was critical to the reputation of the fledgling agency. The road was expected to be the most spectacular drive in America. If the NPS bungled the project, they might never recover.

By the time the NPS was created, there were 15 national parks. The first of them, Yellowstone National Park, was created almost half a century earlier, in 1872. When these early national parks were first established, they were managed by different agencies. Some, such as Yellowstone, were managed by the state in which they were located. Other parks, such as Glacier, had their beginnings as forest reserves under the U.S. Forest Service. Later, the national parks came under the jurisdiction of the Department of the Interior but were managed by the U.S. Army. Over the years, there was no uniform policy for caretaking the parks, other than the Congressional orders that established them "as a public park or pleasuring ground for the benefit and enjoyment of the people." The volume of visitors arriving by train, stage, and—since 1907—by automobile, steadily increased, which only increased the wear and tear on these national treasures. The parks were greatly enjoyed but poorly protected. The parks' scenic wonders were being stressed, and some features were eroding. On top of the

17

preservation problems, there were commercial and political pressures across the nation to exploit the parks' natural resources.

Mather to the Rescue

In 1914, the retired "Twenty-Mule Team" Borax millionaire Stephen Tyng Mather made a trip through Sequoia and Yosemite National Parks. Mather was an avid mountain climber and a dedicated conservationist. Greatly troubled by the deteriorating conditions of the national parks, he wrote to his college friend Franklin Lane, the secretary of the interior, criticizing the mismanagement of the nation's parks.

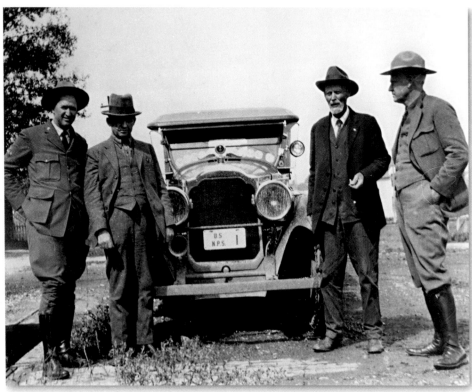

Some important players in the Going-to-the-Sun Road. From left, Horace M. Albright, assistant to National Park Service director; Jimmie Johnson, White Sulphur Springs, Montana; Charles W. Cook, 1869 Yellowstone explorer; Stephen T. Mather, the first National Park Service director. The men are gathered in front of Mather's Packard, at the home of Cook. COURTESY OF NATIONAL PARK SERVICE, HARPERS FERRY CENTER.

Lane wasted no time in replying. "Dear Steve," Lane wrote, "If you don't like the way the national parks are run, why don't you come down to Washington and run them yourself?" Lane offered Mather a job responding to the complaints of the various park administrations and creating a recommendation on how the parks should be managed. Lane punctuated his offer with "I can't offer you rank or fame or salary—only a chance to do some great public service."

Mather couldn't pass up the challenge. Protecting the nation's scenic lands was too important to walk away from. The 47-year-old mountain climber agreed to take the job for one year. Tackling the task with his characteristic energy and tireless determination, Mather sought to bring all the parks under one single, separate bureau so their purposes and policies would be consistent. When Congress established the NPS the following year, in 1916, Mather was persuaded to stay on as the first director, a post he held until his death in 1929.

The young, like-minded Horace Albright, who would later succeed him as the NPS director, was Mather's assistant. Together, they created long-lasting policies that governed the management of the nation's scenic and historic

resources and the stewardship of America's national parks.

High Roads and Low Roads

Automobiles were becoming a major part of American life, and the public was clamoring for new roads to every corner of the nation. In 1916, when the NPS was formed, some national parks, including Mount Rainier and Yosemite, were already accessible by automobile. For years, Yellowstone, the nation's first and largest national park, had resisted permitting automobiles inside park borders to avoid conflicts with horses. But in 1915, prompted by a change in policy, Yellowstone zealously provided 350 miles of roads accessible to automobiles. When Mather—a proponent of automobile roads in national parks—became director of the NPS, he lifted the remaining restrictions on allowing automobiles in parks and lowered motoring fees.

Although Mather strongly supported building roads in the national parks and worked diligently to get Congress to provide funding, he deeply feared that poorly planned roads would damage the lands they were built to showcase. In a report to Congress, he vowed that wouldn't happen. He wrote that "our

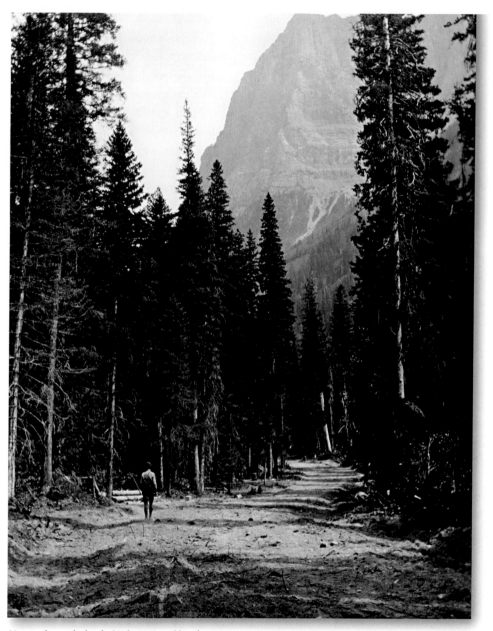

New road near the head of Lake McDonald in the 1920s. COURTESY OF GLACIER NATIONAL PARK ARCHIVES.

purpose is to construct only such roads as contribute solely toward accessibility of the major scenic areas by motor without disturbing the solitude and quiet of other sections." He pushed for the creation of a single, scenic road, rather than a network of roads, through each park. And he gave his chief civil engineer, George E. Goodwin, the task of choosing the most desirable projects in each park, surveying the sites, and preparing plans. When funding was available for park roads, Mather wanted to be ready.

George Goodwin was a handsome, silver-haired man with a tendency toward pomposity. A recognized authority on mountain road construction, Goodwin had honed his road engineering skills building railroads and working on government reclamation projects. When he was 39, he went to work for the Army Corps of Engineers for four years, and in 1917 he was hired by the NPS. Shortly after he arrived, he was temporarily assigned as acting superintendent of Glacier National Park to fill an unexpected vacancy. During the two months Goodwin was at the park, he made a reconnaissance survey for a road across the mountains over Logan Pass. He returned to Glacier National Park the following year to complete the location survey.

For the next three years, most of the funds authorized by the Federal-Aid to Highways Act of 1916 went to construct highways in national forests and roads connecting to national parks, rather than roads inside the parks. In 1919 and 1920, Congress did not allocate any funds for park road construction. Goodwin's 1918 survey for Glacier's Transmountain Highway and his proposals for other national park roads languished on desktops and in files. But in 1921, Mather's push to get funding for park roads began to meet with some success. The NPS received just enough federal funding to start three projects—the Carbon River Road in Mount Rainier National Park, the Generals Highway to the Giant Forest in Sequoia National Park, and the Transmountain Highway in Glacier National Park.

The Transmountain Highway enjoyed a high priority among the NPS's road projects. The governor and the Montana

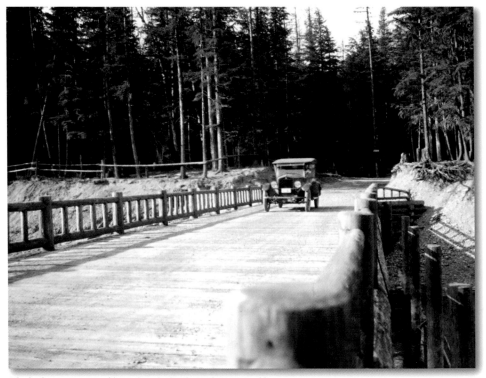

The bridge over McDonald Creek at the head of Lake McDonald. COURTESY OF GLACIER NATIONAL PARK ARCHIVES.

state legislature had long urged Congress to fund the construction of a highway through Glacier National Park that would connect with the existing highways that ran east to the Great Lakes and west to the Pacific Coast. The Transmountain Highway would also serve as the missing link in the great loop of western parks that would connect Yellowstone, Glacier, and Mount Rainier National Parks in the Park-to-Park Highway System. The concept of a park-to-park highway system had been suggested in 1915 at the dedication of Rocky Mountain National Park. The idea was enthusiastically supported by Mather, and aggressively promoted throughout the West by the Interstate Wonderland Trail Association, the Southern California Automobile Association, the Washington Good Roads Association, and the National Park-to-Park Highway Association.

Small amounts of funding for roads began to flow to the NPS in 1921, and during the next few years, the first 20 miles of the Transmountain Highway were built, graded, and graveled. The park hired laborers to clear an 11-mile stretch of right-of-way from Logan's 1911 Apgar Road at the foot of Lake McDonald to upper McDonald Creek.

By late summer in 1921, motorists could drive to Lewis's hotel at the head of Lake McDonald for the first time. In 1922, road work proceeded along upper McDonald Creek and ended near Avalanche Creek. In 1924 and 1925, the road was extended to Logan Creek.

On the east side, the NPS graded and extended the wagon road from the village of St. Mary to Roes Creek that the Great Northern Railway had built in 1912. Then the NPS issued contracts in 1923 to construct and grade a road from Roes Creek to a point about two miles east of Sun Point.

In 1924, Congress passed legislation authorizing a whopping $7.5 million for roads, trails, and bridges in national parks over the following three years. Mather, delighted with the funding he had so long sought, was now faced with the crucial task of making the final decision on the location and design of the park roads.

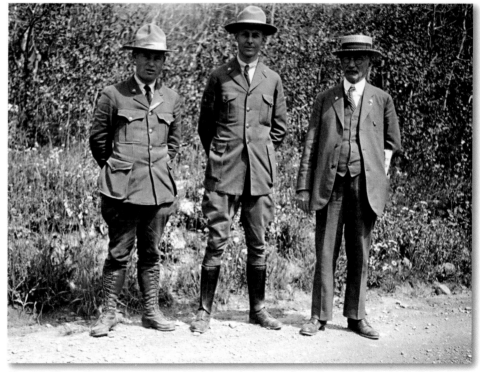

From left, Thomas Vint, assistant to National Park Service landscape architect Daniel Hull; Charles Kraebel, Glacier National Park superintendent; and Dr. Morton Elrod, Glacier National Park naturalist.
COURTESY OF NATIONAL PARK SERVICE, HARPERS FERRY CENTER.

The reputation of the NPS hung on the successful construction of the high-profile Transmountain Highway through the heart of Glacier National Park. With Goodwin's 1918 road plan in hand, Mather went to Glacier to inspect the proposed route over Logan Pass. George Goodwin was with him. They were joined by Charles Kraebel, the new superintendent of Glacier National Park, and Thomas Vint, the eager young assistant to NPS landscape architect Daniel Hull.

The four men spent the day riding on horseback over the Continental Divide to inspect Goodwin's preliminary survey route. A few miles west of Logan Pass, the men dismounted and, according to park files and the National Historic Landmark nomination, stood on the mountainside, taking in "the view of Logan Creek Valley below and the summits of the Livingston Range that mark the Continental Divide. Flanked on one side by the huge almost vertical cliff called the Garden Wall, the green valley of Logan Creek provided the foreground of a stunning panorama of the Glacier high country. The vista captured the very heart of the park: a region containing dozens of lakes and glaciers and scores of jagged, alpine peaks."

As they took in the view, each man was envisioning a road running through this steep, beautiful, and forbidding place. It was a pivotal moment for the future of all national park roads.

Goodwin envisioned a road designed in the fashion of many European scenic roads, with a series of switchbacks climbing up and down the mountainside. In his 1918 survey, much of Goodwin's proposed route over the mountains through Logan Pass was in the shadowy canyons of Logan Creek Valley. The route used 15 switchbacks to rise to the summit, at an eight percent grade in some places. On the eastern slope, the road dropped into the St. Mary Valley by way of three switchbacks. Park visitors traveling over the upper stretches of Goodwin's road could look down and see several sections of the road below. Goodwin believed that this spectacular engineering would be an attraction in itself. It was also the most practical and least expensive way to build the Transmountain Highway, which all of Goodwin's training and experience had taught him was the most important consideration in building difficult mountain roads.

Thomas Vint, the short, amiable, slightly overweight landscape architect, had other ideas. His meager experience planting for nurseries and working as a draftsman and a landscape architect for two years for the NPS was no match for Goodwin's long and distinguished career in mountain road engineering. Nevertheless, the upstart landscape architect bravely stepped forward.

Risking the ire of the veteran engineer who had been in charge of the nation's park roads since 1917, Vint began to talk. He described the effect that Goodwin's 15 switchbacks would have on the scene they were all admiring. The switchbacks, he said, would make the beautiful landscape before them look "like miners had been in there."

Vint urged Mather to replace the series of switchbacks with a longer road along the face of the Garden Wall that gradually descended to a single switchback dropping to the road along McDonald Creek. "If this roadway could be benched into the sedimentary rock of the Garden Wall all the way down the valley," he noted, "the scene below would be preserved completely untouched."

Vint's plan, however elegant, was considerably more expensive. It called for a much longer road that had to be carved into solid rock. If it could be done at all, it would most likely deplete

all of the funds available for the nation's park roads.

Mather, who had listened to both proposals, was silent.

"This is a big thing," Vint persisted. "This job is important enough for you to hire the best engineer and the best landscape architect in the country to look after."

"Mr. Mather," Goodwin responded, "there is nobody in the United States that knows as much about road building in the mountains as I do."

Mather didn't say a word. Visibly angry, he abruptly gathered up his reins, mounted his horse, and rode down the trail before Vint, Goodwin, and Kraebel could get in their saddles.

Mather sought other opinions. He consulted with Bill Austin, a Bureau of Public Roads engineer who had impressed Mather with the road work he had supervised in forests near Jackson Hole, Wyoming. Mather asked Austin to come to Glacier and offer his opinion on Vint's Garden Wall alternative to Goodwin's Logan Valley route.

Austin, Vint, and Kraebel spent several days going over Vint's proposed route. They determined Vint's route would more closely meet the policies of the NPS to preserve the scenic landscape, but building the road in the rock face of the Garden Wall would be a monumental engineering project. They talked late into the night and concluded that the NPS and the Bureau of Public Roads each had their own area of expertise to bring to the project and should work together. The three men drafted a proposal for an agreement between the NPS and the Bureau of Public Roads to evaluate and build the Transmountain Highway.

When they were done, they drove to Yellowstone National Park to talk with Mather's assistant, Horace Albright, who had replaced the disgruntled and recently retired George Goodwin as the NPS's expert on road policy. Albright liked the idea. A short time later, Mather and Albright officially negotiated the interbureau agreement with the Bureau of Public Roads. In the agreement, the NPS retained control over when, where, and how park roads would be built to ensure they met the park's standards for scenic preservation. The Bureau of Public Roads agreed to use their engineers to make surveys, prepare contract specifications, supervise construction, and ensure the roads met the bureau's standards for road construction.

The collaboration between the NPS and the BPR initiated by the Transmountain Road that day set a policy for all future National Park Service roads and is in effect today.

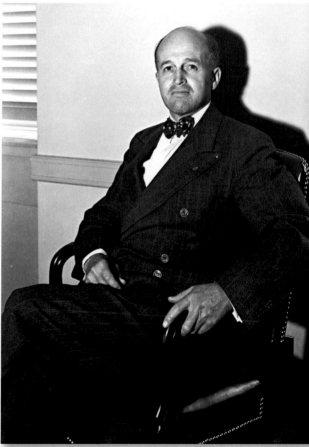

Frank A. Kittredge, senior highway engineer for the Bureau of Public Roads.
COURTESY OF NATIONAL PARK SERVICE, HARPERS FERRY CENTER.

Lying Lightly on the Land

In those days, road surveys were made in three graduated levels of precision. The first level was the reconnaissance survey of the Garden Wall route that had been made by Vint, Austin, and Kraebel. The more detailed preliminary and location surveys were yet to be made. The Bureau of Public Roads sent their senior highway engineer, Frank A. Kittredge, to survey the Garden Wall route and to compare Goodwin's proposed road to Vint's.

Mather wanted Kittredge to recommend the route that best met two criteria. He wanted to satisfy the road construction standards of the Bureau of Public Roads. He also wanted to uphold the NPS goal of building roads that minimized the amount of damage to the scenic landscape, a practice known as "lying lightly on the land."

The 41-year-old Kittredge was already a distinguished road engineer, but the Going-to-the-Sun Road was his most noteworthy project, and it set the precedent for the location and construction of all future park roads. Kittredge went on to become the NPS's chief engineer and the NPS Region Four director who led the movement to add California's Kings Canyon and Washington's Olympic Peninsula to the national park system. He was also the superintendent of Yosemite and Grand Canyon National Parks.

Kittredge arrived at Glacier in mid-September 1924 and immediately began to organize survey crews. The NPS was in a rush to take advantage of the windfall of funds and wanted to begin construction on the road as early the following spring as snow conditions would permit. Kittredge's surveys had to be completed that fall to provide contractors with the necessary information for their bids and to give the NPS time to choose a contractor by early spring. This meant the crews had to design and survey the road during harsh fall weather and finish before the snows of winter drove them off the mountains.

According to Vint, Kittredge was the bureau's "man that they sent out on all the trouble jobs.... Kittredge could work like a dog." Vint was right. When he surveyed the proposed roads across Glacier, Kittredge set up two camps and hired a 32-man survey crew. Kittredge and his men had to make long, steep hikes over cliffs and through brush from the base camps to the job sites daily. They worked on hazardous slopes in rain and sleet. It was tough going, and for many of his survey crew it was too tough. As Kittredge noted later, it was necessary to hire 135 men to keep a 32-man crew on the job because "there were really three crews—one coming, one working, and one going."

The survey crews made it as far as the east side of Logan Pass by November 5, 1924, when four feet of snow ended the survey. Fortunately, Kittredge had completed the preliminary survey and had gathered enough location data to finish planning the road. He photographed the rugged Glacier country and inked in the proposed road alignments across the photos. These marked-up photographs were a visual display of a daunting task.

Kittredge submitted the report to the NPS in February 1925, recommending the Garden Wall route and estimating the project at under $1.3 million. It was the most formidable road construction project ever undertaken by the Bureau of Public Roads and the NPS, and it would take most of Glacier's budget for several years. But to Mather, Vint, and Kraebel, it was the right thing to do.

In Vint's comments about the survey, he noted that the route provided views of Glacier's scenic features in their proper proportions. He was especially pleased that the road featured the scenery and not the road itself. "One might say," he wrote in a memorandum to his supervisor Daniel Hull, "it performs its work more silently."

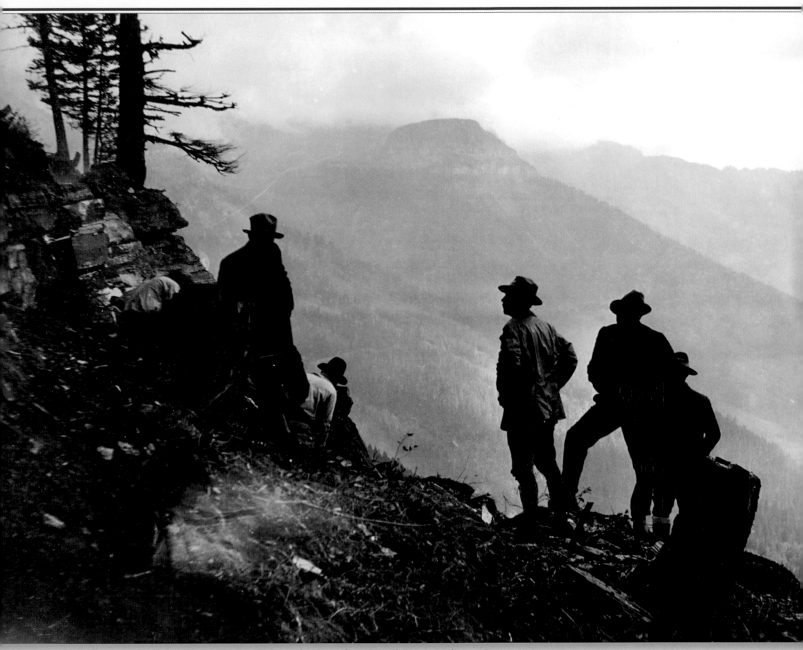

Engineers near the present-day Loop look over the terrain along Haystack Butte toward Logan Pass. COURTESY OF GLACIER NATIONAL PARK ARCHIVES.

The Daunting Task Ahead

In Frank A. Kittredge's 1925 Survey Report, the line (changed to red for clarity) drawn across these October 1924 photographs indicates the route the Transmountain Highway was to take through the heart of Glacier National Park.

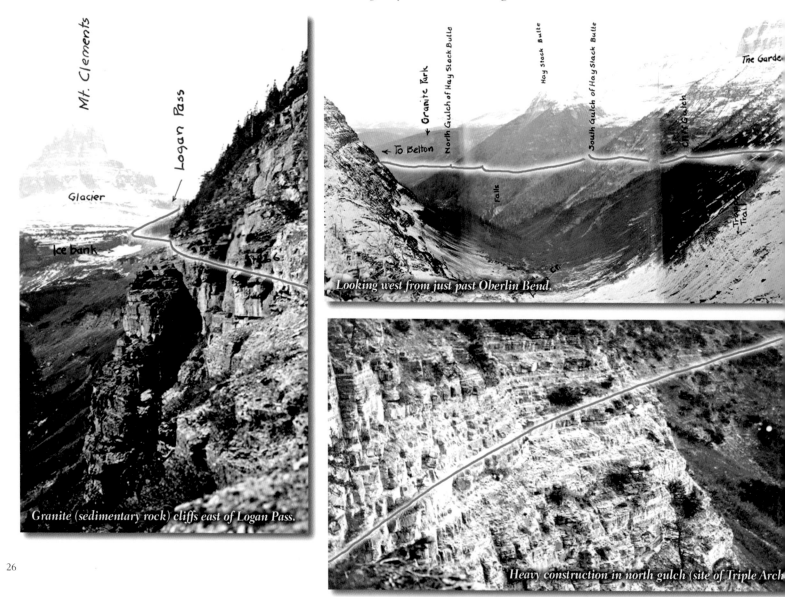

Granite (sedimentary rock) cliffs east of Logan Pass.

Looking west from just past Oberlin Bend.

Heavy construction in north gulch (site of Triple Arch

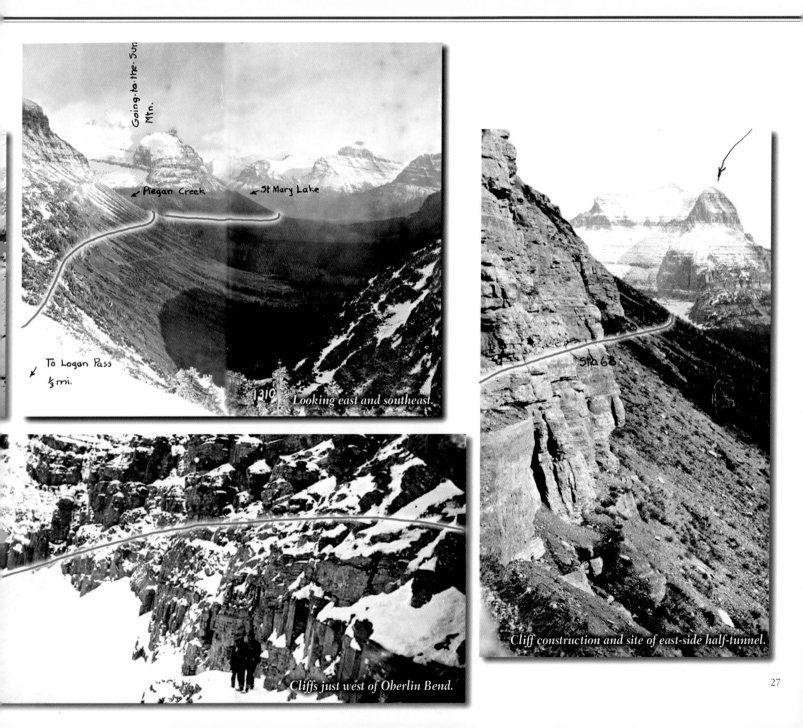

Going-to-the-Sun Mtn.

Piegan Creek

St Mary Lake

To Logan Pass ½ mi.

1310 Looking east and southeast.

Sta 68

Cliff construction and site of east-side half-tunnel.

Cliffs just west of Oberlin Bend.

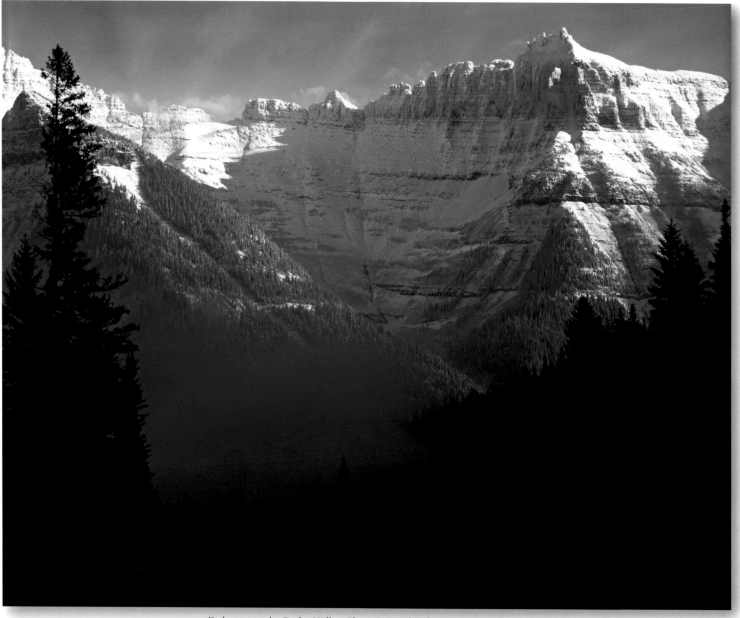

Early snow on the Garden Wall in Glacier National Park. PHOTO BY JOHN REDDY.

4

THE IMPOSSIBLE TAKES A LITTLE LONGER

"Well, the impossible takes a little longer, but the difficult we do immediately."
—GOING-TO-THE-SUN ROAD ENGINEER, 1925

Kittredge's survey was completed in February 1925. By the middle of May, the survey and construction specifications for the west-side road had been thoroughly reviewed and approved by the government. On May 21, 1925, potential contractors were invited to take a look at the job and submit their bids.

A few days later, 35 tough-minded prospective contractors trudged up the snow-covered mountains of Glacier National Park on snowshoes to take a firsthand look at the country and the work to be done. They were seasoned mountain road builders from all over the West. These men knew that all roads that crossed the rugged Rocky Mountains were brutally difficult to construct, but the Transmountain Highway bordered on the impossible. What made it infinitely more difficult to build was the National Park Service's (NPS) construction standards to "protect the landscape" above all else. The

country was wild, steep, and unforgiving. It was going to be a hell of a job.

The less-challenging low stretches of the Transmountain Highway that ran from West Glacier to Logan Creek and

from St. Mary to two miles west of Roes Creek (or what is now Rising Sun) had already been graded and partially graveled by 1924 and would be completed during 1925. The most

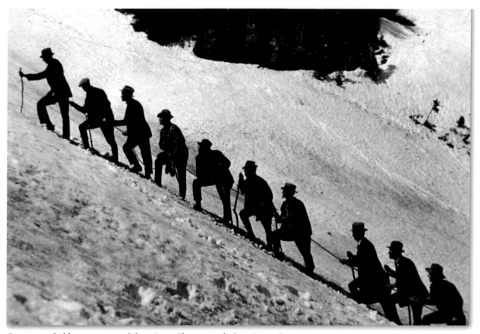

Prospective bidders on a snow slide at Jones Flat, one mile from Logan Pass. COURTESY OF GLACIER NATIONAL PARK ARCHIVES.

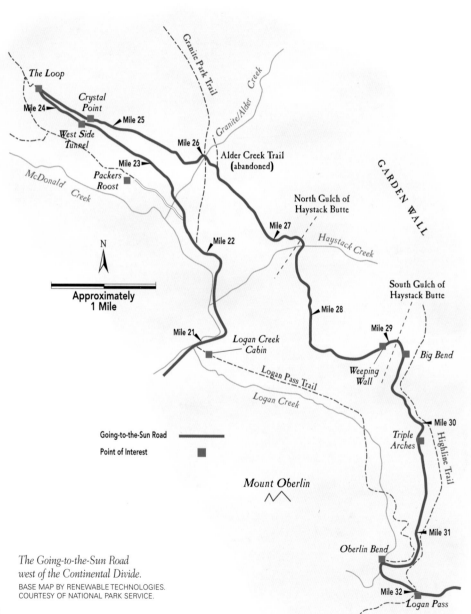

*The Going-to-the-Sun Road
west of the Continental Divide.*
BASE MAP BY RENEWABLE TECHNOLOGIES.
COURTESY OF NATIONAL PARK SERVICE.

difficult and hazardous part of the road construction lay ahead: the nearly 12½ miles from Logan Creek up to Logan Pass and the 10½ miles over Logan Pass and down the east side of the Continental Divide that would connect with the St. Mary road.

The NPS decided to complete the road on the west side of the divide first. It would take four years. Work on the east-slope road would begin in 1931, and would take two years.

West of the Divide

Construction bids were opened on June 10, 1925, and a day later the Williams and Douglas Construction Company of Tacoma, Washington, with the low bid of just under $900,000, was awarded the contract. As soon as the contract was signed, Williams and Douglas began moving equipment to Glacier, signing with subcontractors, and rounding up laborers for the work ahead.

The road Douglas signed up to build climbed to the northwest from Logan Creek, along McDonald Creek to 4,300 feet, and then switched back to the east, climbing continuously at a grade of six percent, traversing the Garden Wall formation along the contours of Haystack Butte and Pollock Mountain to Logan Pass.

The road had to be benched into the sheer sides of the Garden Wall, and plans called for one cave-like tunnel and several cliff overhangs, known as half-tunnels. Construction also included building three bridges, several culverts with masonry arch facades, and native stone retaining walls and arches as well as a switchback that would be made into a graceful loop. Along the most dangerous drop-offs, 18-inch-high native stone guard walls were to be built to protect motorists from plunging over the edge.

Park landscape architects carefully designed these features to blend with their natural surroundings. Most of the work was done with hand tools to reduce the impact on the land. In the course of the construction, however, Douglas was able to convince the NPS to allow them to use power shovels for rock excavation.

The Bureau of Public Roads assigned W. G. Peters to oversee the project. He had arrived at Glacier in May, a day before the contract was advertised for bid. Peters was accompanied by four assistants from the bureau and a Glacier National Park ranger. The ranger had been assigned by Glacier National Park superintendent Charles Kraebel to make sure the contractor followed the NPS guidelines for landscape and fire protec-

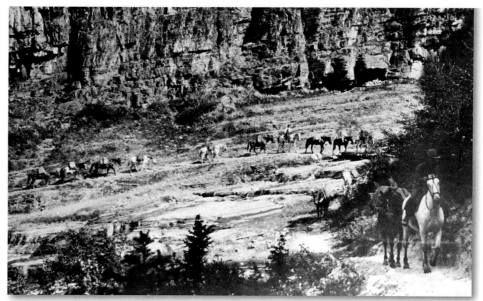

A pack string of horses and several unknown workers in 1926 on the Logan Pass Trail.
PICTURE FROM DEPARTMENT OF AGRICULTURE, MOVING PICTURE DIVISION. COURTESY OF GLACIER NATIONAL PARK ARCHIVES.

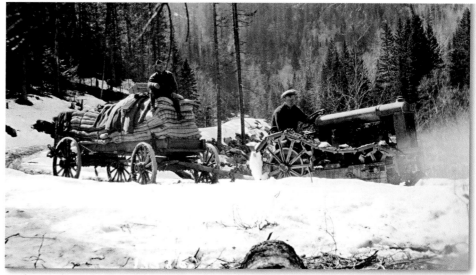

Hauling supplies on the Mount Cannon section of the road from Belton to Camp 1 at Logan Creek in 1926.
CONSTRUCTION REPORT BY W. G. PETERS. COURTESY OF GLACIER NATIONAL PARK ARCHIVES.

tion. The government men worked out of the NPS headquarters near Apgar until the project headquarters at Camp 1 at Logan Creek was set up.

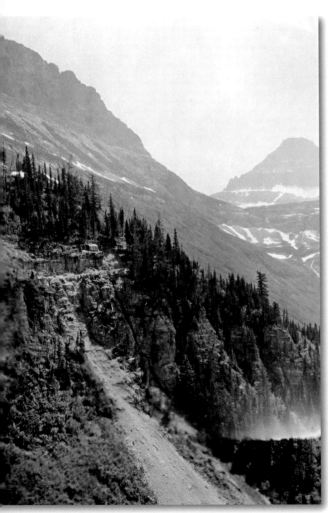

Camp 5, located just above the present-day Triple Arches, between 1927 and 1928. COURTESY OF GLACIER NATIONAL PARK ARCHIVES.

The ink on the contract was barely dry when Archie R. Douglas, who became the on-site boss for the Williams and Douglas Construction Company, and his subcontractors rolled in to the job site at Logan Creek and began setting up the headquarters camp. Douglas, surrounded by the windstorm of activity that accompanies a new construction project, pinned survey maps and schedules to the hastily built walls of the camp headquarters and shouted orders to subcontractors who, in turn, barked at the foreman and laborers who were building the supply cabin and mess hall and putting up tents to sleep 50 to 60 men. Their voices were barely audible over the whine of truck engines and the rhythmic rattle of horse-drawn wagons bringing in loads of lumber, crates of tools, hay for horses, fuel for compressors, barrels of food, pots, pans, cots, and tents. Packers were leading in strings of pack and saddle horses, and trail-building crews were hiking up the mountains to begin work.

As soon as Camp 1 was somewhat set up and functioning, the crews assigned to build camps packed tools, lumber, and tents up to Camp 2, the site of the switchback that is now known as The Loop. There was little level ground on the mountain at this site to set up the tents. Douglas was prohibited from making cuts in the mountains or destroying vegetation by clearing areas other than on the road right-of-way or on the necessary access trails. Douglas ordered the tent platforms to be put on stilts to both level the tents and avoid damaging the vegetation underneath. The next year, four more camps were set up, some of which also had the tent platforms mounted on stilts.

While men were setting up Camp 1 at Logan Creek and Camp 2 at The Loop, trail crews were already on the mountains widening and clearing the existing trails to Granite Park and Logan Pass. The Granite Park Trail was used to reach the Granite Park site where Camp 3 was built the following year. From the Granite Park site, crews then cleared a trail to the North Gulch of Haystack Butte, where Camp 4 was to be located. The old Logan Pass Trail from Logan Creek to Logan Pass was used to reach the Camp 5 site above what is now the Triple Arches, and Camp 6 at Oberlin Bend. During the building of the westside road, trail crews also built more than 15 miles of temporary trails to

provide access to various places along the planned roadway, or to route pack strings of horses around portions where heavy blasting made travel impossible or too dangerous.

The trail crew foreman, Charles Rudberg, was the first fatality during the building of the Going-to-the-Sun Road. He was killed in June 1926 when he lost his grip while descending the cliffs about one mile above The Loop and fell 60 feet. According to packer Joe Opalka, who worked in Glacier from 1925 to 1927, "some of the men didn't feel too sorry about Rudberg. They said it was his own fault…a man with feet that big…over-stepped and killed himself."

Everything that was needed in the camps, except whiskey, which the men had to bring in themselves, was hauled up by pack strings from the headquarters camp at Logan Creek. Horses loaded with lumber, drilling steel, explosives, tools, culverts, compressors, food, equipment, and all supplies wound their way up the steep mountain trails to the camps. Equipment that couldn't be packed on the animals was dragged up by sled or travois. Once the camps were operating, some 60 pack horses and 10 saddle horses were used to bring in supplies.

Opalka was one of six packers. He was paid $5 a day plus $1 a day for each horse he used. "We had 20 to 30 head, although we couldn't use them every day," Opalka recalled in a 1990 interview with the NPS. "It was too much work for them with the trail so steep, so we had to keep them rested. Only a few pack horses were necessary for the trips to the lower camps. But the trips to Camps 5 and 6 took all day with a full string. We used three men with two strings: one man in the lead, one in the middle between the strings, and one at the end. You couldn't dare pigtail them, because if you lose one over the edge, you lose them all."

One of the pack horses did go over the cliffs above Camp 4 at the North Gulch of Haystack Butte. The horse was packed with three 50-pound boxes of powder. It slipped over the side and rolled "clean down to the bottom—but the powder never exploded." Although the horse was Roanie, one of his favorites, Opalka gave up the horse for dead and led the rest of the string to Camp 4 and unloaded, then returned to the headquarters camp. After supper, he rode a

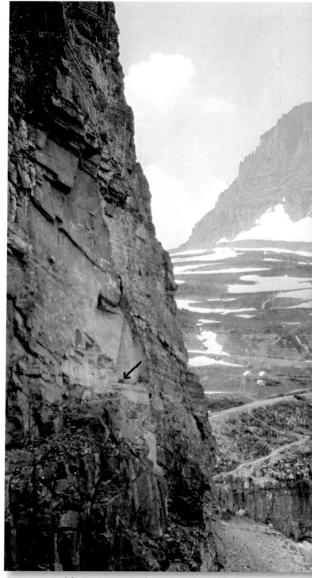

Construction of the Logan Pass Trail in 1927. The trail had been partially excavated to the dynamite box, indicated by the arrow. On the ground below, you can see the canvas tents of Camp 6. COURTESY OF GLACIER NATIONAL PARK ARCHIVES.

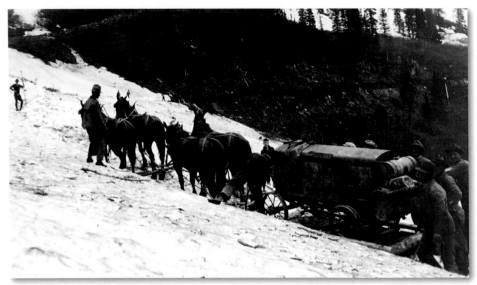

Moving a compressor across a snow slide 50 feet deep at the South Gulch of Haystack Butte in July 1927.
COURTESY OF GLACIER NATIONAL PARK ARCHIVES.

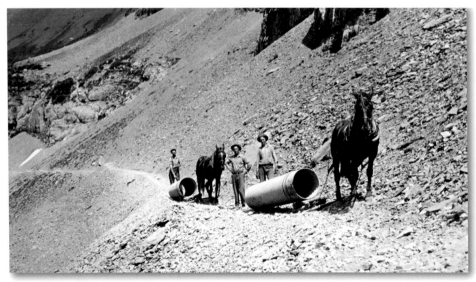

These men are using "go-devils," or horse-drawn travois, to haul culvert pipes, steel rails, and air pipes on the old Granite Park Trail in 1926. CONSTRUCTION REPORT BY W. G. PETERS. COURTESY OF GLACIER NATIONAL PARK ARCHIVES.

saddle horse up the old Logan Creek Trail to pick up what was left of the pack saddle and halter. Opalka recalled that when he got to where he expected to find the horse's body, "There was that old guy standing in a meadow eating. He had a swollen eye, but no broken bones. I just couldn't feature that, seeing as how he'd rolled from the road all the way to the bottom of the creek."

Men Who Do Things

At the peak of construction, about 300 men were scattered along the mountainsides, clearing access trails, grading roadbed, laying culverts, drilling and blasting, hauling supplies, and keeping camps, as well as building bridges, rubble arches, retaining walls, and guard rails. They worked in teams known as "station gangs" assigned at various locations along the route.

The work was brutally hard and dangerous, but finding men to do a tough day's work for 50 cents to $1.15 an hour was easy in the 1920s and 1930s. It was a good wage for the times. Wages varied according to the skills required for the job. Station gangs were paid by the cubic yard of material they moved. The skilled workers, such as the cat skinners who operated dozers and graders, and the powder monkeys

who blasted openings with dynamite, were paid the most.

The camps were an interesting hodgepodge of Americans and Europeans. Contractors hired seasoned road builders, World War I veterans, and men who were supporting families first. Next they hired young, eager men looking for experience and a start in life—boys who were leaving the farms to make their way in the world, and immigrants eager for a start in their adopted country.

Harold Siblerud was one of the young Montana boys who talked his way into a job on the road. According to his son, Roger Siblerud of Kalispell, Montana, Harold showed up at the job site asking for work as a cat skinner. The foreman told him he was too young and tried to send him on his way. Harold needed work and was not about to give up. He pointed to a man operating a grader. "He's my younger brother, and I taught him everything he knows." The foreman signed him on.

Among the mix of "foreigners" working on the mountain were Swedes, Austrians, and Russians. They all spoke to each other in their native languages, and spoke to the Americans in broken English. Some men were hired because of their special skills. Sixteen Russians who were expert stonemasons were hired as subcontractors to build the

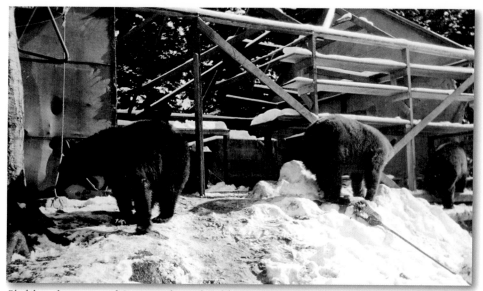

Black bears foraging around Camp 4 in the North Gulch of Haystack Butte. Eight to 12 bears hovered at each camp. CONSTRUCTION REPORT BY W. G. PETERS. COURTESY OF GLACIER NATIONAL PARK ARCHIVES.

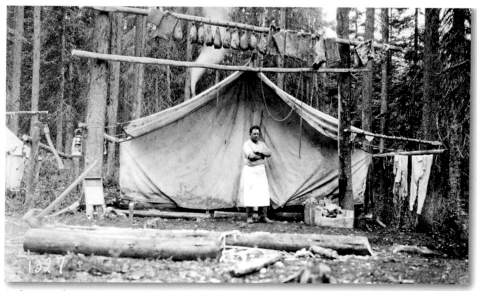

In this 1924 photograph, meat is strung high across a pole, well out of the bears' reach, with a determined "cookie" standing guard. COURTESY OF GLACIER NATIONAL PARK ARCHIVES.

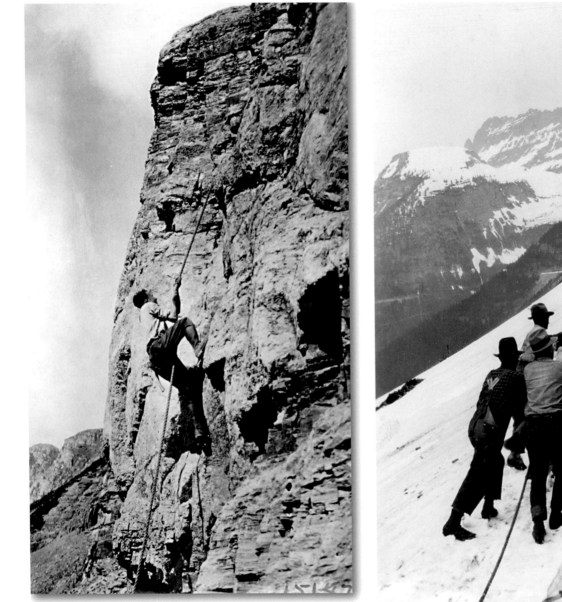

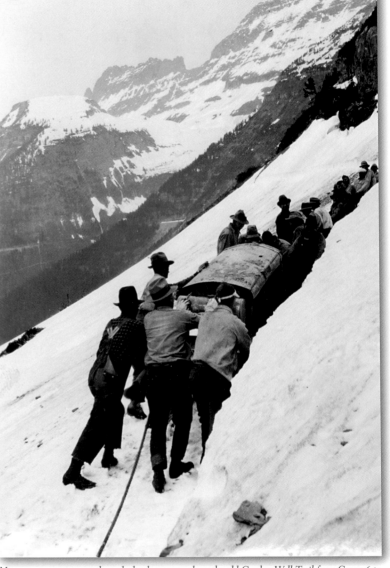

Chainmen take cross-sections to establish the alignment of the road along the cliffs west of Oberlin Bend. CONSTRUCTION REPORT BY W. G. PETERS. COURTESY OF GLACIER NATIONAL PARK ARCHIVES.

Men move a compressor through the deep snow along the old Garden Wall Trail from Camp 6 to work station west of Oberlin Bend, June 22, 1927. COURTESY OF GLACIER NATIONAL PARK ARCHIVES.

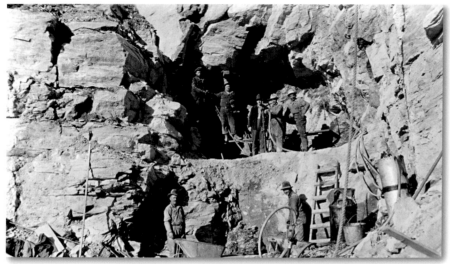

This view of the construction on the east portal shows how workers—powder men, drillers, and muckers—bored the tunnel through rock. CONSTRUCTION REPORT BY W. G. PETERS. COURTESY OF GLACIER NATIONAL PARK ARCHIVES.

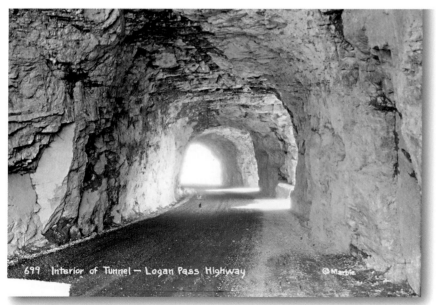

699 Interior of Tunnel — Logan Pass Highway © Marble

The cave-like interior of the finished 1927 tunnel. R. E. MARBLE, PHOTOGRAPHER. COURTESY OF GLACIER NATIONAL PARK ARCHIVES.

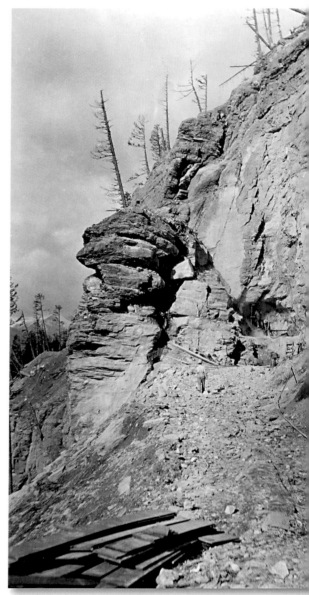

Taken during construction of the east portal, this October 1926 photo shows how the rock's formation and faults required shifting the tunnel's centerline as it bore through the cliff. CONSTRUCTION REPORT BY W. G. PETERS. COURTESY OF GLACIER NATIONAL PARK ARCHIVES.

rock retaining walls, including the Triple Arches. In his interview with the NPS, Opalka said the Russians sounded "like a bunch of geese when you heard them talk, but I'll tell you they were workers." He heard them working late into the night, and once he watched three of them cutting blast holes in boulders. As the Russians swung their sledgehammers, Opalka said, "They never slipped hands on the handle, just over and over, bangety-bang just like a jackhammer."

Cat skinner Harold Siblerud recalled in an interview in the *Hungry Horse News* that "there was one time when they put me in a tent with some foreigners. I couldn't understand what they were saying, whether they were talking about me or not."

Then Siblerud went on to tell what

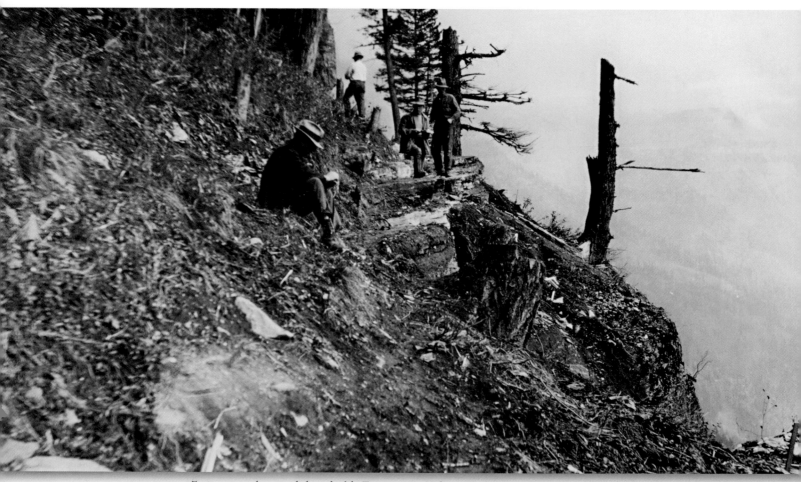

Engineers set stakes to mark the path of the Transmountain Highway. COURTESY OF GLACIER NATIONAL PARK ARCHIVES.

he thought was one of the most memorable stories he remembered about those times in the mountains. There had been an explosion, and folks were gathering around. He said, "This big Austrian called Tarzan went running down the road to see what happened." When he returned to tell Siblerud what had occurred, Tarzan said, "Oh, it was nothing. Just a Swede got killed."

Despite the mishmash of skills, languages, and dispositions, and the occasional hot-tempered squabble, on the whole the men got along well. They took a robust pleasure in the hard work, in the risks, and in recounting them in glorious detail in the evening over coffee, tea, or whiskey. Every morning they hiked out to their job sites, and each evening they trudged back after their long day's work. They lived in tents on mountaintops, and they ate well. The food was always good. Next to the powder monkeys, the most important man in camp was the cook. If the food wasn't good, a new cook would be there in the morning.

Protecting their lunches from bears added another lively adventure to life in the mountains. The men clearing trees from trails and from the right-of-way worked crosscut saws halfway into trees as barriers, and then hung their lunches above the saw. Camp cooks tried several schemes to keep the camp meat from

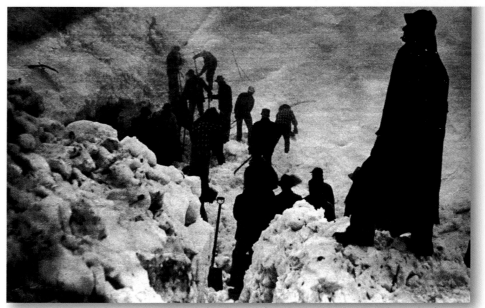

As workers dig through the snow, an avalanche lookout listens and watches for signs of an impending avalanche.
COURTESY OF GLACIER NATIONAL PARK ARCHIVES.

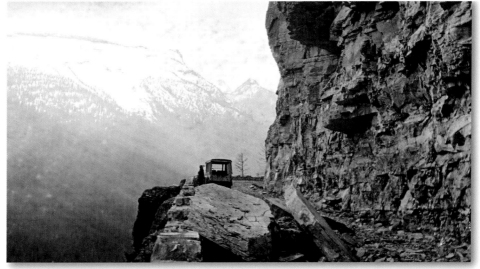

This June 1928 photograph shows the large rocks that have fallen from the half-tunnel.
CONSTRUCTION REPORT BY W. G. PETERS. COURTESY OF GLACIER NATIONAL PARK ARCHIVES.

the bears, including studding sides of meat houses with nail points and hanging meat on long poles high above the cook tent. Later on, cooks began to feed the bears regularly and that seemed to keep the black and small brown bears from stealing lunches. Grizzlies, however, were not so easily satisfied. Park rangers were stationed at each camp to keep them under control.

The men building the road were continuously faced with dangers from above and below them. In early spring, avalanches threatened to tumble them off the mountains. On many portions of the road, lookouts were posted to watch and warn the men if an avalanche was coming. When the avalanche season was over, there was still the danger from tumbling rocks. Men working on the lower line of the road along McDonald Creek were in constant danger from the falling rocks that were loosened by the dynamiting work on the upper line above the switchback and along the Garden Wall.

Although tin hats for safety were not commonly used in those days, some men risked the good-natured ribbing of their fellow workers and wore war surplus "head buckets" to protect against the falling rocks. There were numerous injuries, but no one working on the west side of the road was killed from falling rocks. On the east side of the divide, Carl Rosenquist, a worker from Spokane, was killed by a falling rock in August 1931.

Cat skinners shoving piles of rubble from blasting areas and grading road on steep mountainsides occasionally had to jump to safety as their bulldozer or grader plunged over an unstable embankment. Some workers were hurt and some equipment was badly damaged, but the fact that no one was killed in these instances is a testament to their ability to react quickly.

Wagon team handlers and dump truck drivers hauling away rubble blasted from the mountainside faced their own sets of hazards. They drove heavy, unstable loads over treacherous roads in unpredictable weather. Somehow they managed to stay on the road. Only a few incidents of dump trucks rolling over the edge of cliffs were reported. There were injuries but no deaths.

Field engineers were some of the toughest men working on the road. They worked far ahead of the construction crews, triangulating the alignment of the road to be cut through the mountains. Field engineers lugged cameras, measuring instruments, survey maps, stakes, and ropes over snow-covered, windswept mountains, clinging to icy crevices on the face of steep cliffs to get to survey points. Where the road was to be built along the face of steep cliffs, the field engineers climbed up to the mountain ridge, tied ropes to the nearest tree, and hung over the edge on the ropes to run the center lines and cross-sections. The work required skill, strength, and steely resolve to literally "hang in there." A misstep meant death. Adding to the danger was the threat of falling rocks. The engineers had many narrow escapes but only one was seriously injured. He fell from the top of a rock outcrop to the road below and spent a week in a hospital.

Fifteen engineers were stationed at four different camps in 1926. Most of the engineers stayed for 1927 and 1928, but a few men broke under the stress and walked off the job.

In his final construction report for the west-side road, project engineer W. G. Peters credits the success of constructing the road to the capability of the young field engineers. He wrote that there were "no very unusual engineering features" in the project, and that the "cliffs only required much slow, hard, dangerous work to secure the cross-sections and to project and stake the line. At the tunnel, the cross-sectioning was of a similar nature. Here, however, good judgment had to be exercised in fitting the tunnel to the line of least possible trouble from rock fissures. The Loop required much work, study, and design-

ing. Much credit is due the young men who so capably and loyally assisted throughout the work."

There were numerous injuries, but according to NPS records only three workers died while working on the Going-to-the-Sun Road: the trail crew foreman who was killed in 1926 and two more men who died while working on the east-side road. One was struck by a falling rock in 1931, and the other, a stonemason, was killed near Logan Pass in 1932 when he fell from the road 400 feet down the mountain.

Along McDonald Creek

By the end of 1925, the camps at Logan and The Loop had been set up, and the roadway from Logan Creek to well past The Loop had been cleared and grubbed. The lower road from Logan Creek that parallels McDonald Creek was in various stages of construction. A tunnel through the overhanging cliff section about 2,000 feet from The Loop was yet to be holed.

While clearing and grubbing crews sawed down trees and dug up roots and stumps, an Osgood ¾-yard gas shovel was right behind, working its way along the lower sections of the road, scooping up stumps and boulders and dumping them into wagons to be hauled off the roadway. By then, Douglas had convinced the NPS to let him use gas-powered shovels rather than picks, shovels, crowbars, and wheelbarrows to clear the road right-of-way and load the blasting rubble onto the wagons to be hauled away.

Above the men working along McDonald Creek, station gangs along the Garden Wall were blasting day and night to carve a bench for the road into the cliffs from The Loop to Logan Pass.

The men working along the Garden Wall were using muscle and crowbars to move the blasting rubble off the bench. Douglas needed to get a gas-powered shovel up there to clear the bench faster, but the road up to The Loop was blocked by the cliff, which would later be tunneled. To solve this problem, Douglas got permission from the NPS to build a tote road to move the Osgood ¾-yard gas shovel past the tunnel site up to where the road above The Loop was being built. The Osgood ¾-yard gas shovel operator made his way slowly along McDonald Creek. The men left the road right-of-way at the Granite Creek crossing and moved below the roadway, cutting a tote road that paralleled McDonald Creek. Between The Loop and the proposed tunnel site, he turned up the mountain and climbed his way up the steep mountainside to the upper road. It was October and winter was settling in. Work on the road in 1925 had to stop. The shovel was left standing where it was shut down. When work began again the

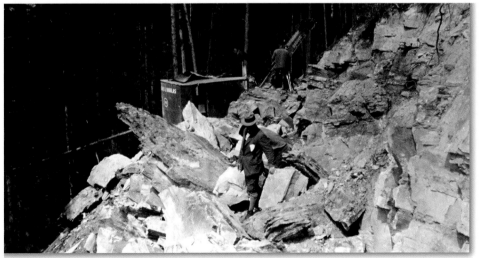

A power shovel excavates rock between the West Side Tunnel and The Loop.
CONSTRUCTION REPORT BY W. G. PETERS. COURTESY OF GLACIER NATIONAL PARK ARCHIVES.

following April, the operator coaxed the shovel into starting up and began working his way toward the upper roadway.

The tote road was used to take supplies and equipment to Camp 2 at The Loop and up to the men working along the Garden Wall until the tunnel on the road below The Loop was created in 1927 and shovels, wagons, and dump trucks could get through.

The West Side Tunnel

Work on various sections of the road continued throughout the 1926 work season. However, the road to the tunnel site was not cleared until October. When the tunnel crews were finally able to get to the site, they were in a hurry to bore the tunnel before winter set in. The foreman, powder man, drillers, chuck tenders, muckers, nipper, blacksmith, and compressor man worked double and triple shifts. The men used Sullivan air compressors, hydraulic pressure, and 60 percent dynamite to drill, blast, and jackhammer a tunnel that was 192 feet long and 18 feet high through the side of the mountain. It was a brute of a job. At the end of October, when most of the other operations on the road had shut down for the winter, the tunnel crew kept drilling, blasting, and hauling out rock. Only a short distance remained to break through

the west portal by mid-December. But when temperatures dropped to 32 degrees below zero, the tunnel crew reluctantly came off the mountain.

Early in April 1927, the tunnel crew was back at it. They broke through the west portal, widening the tunnel enough to allow construction equipment to pass through, and blasted two observation windows through the tunnel walls. The windows opened onto a wide shelf of rock on the cliff. Masonry railings were later added for safety. This balcony, perched at the edge of a cliff, provided a grand view of McDonald Creek Valley, 8,987-foot Heavens Peak, and the surrounding mountains.

The exposed rock face of the interior was left unlined to give the tunnel the character of a cave entrance. A mountain stream flowed over the tunnel, splashing onto the automobiles as motorists passed through the tunnel openings, delighting the tourists. Over time, the water began seeping through the seams in the rock and slowly began eroding the stability of the tunnel. Years later, a drainage system was constructed and the tunnel was lined with concrete.

The Loop

It took considerable mountain engineering savvy and hard work to whittle the

switchback out of the side of a jagged mountain outcropping into a graceful 75-foot radius loop. The switchback turns the Going-to-the-Sun Road from its northwesterly direction eastward to climb along the Garden Wall. The men drilled, blasted, and bulldozed heavy cuts in the mountain to carve and shape the road's upper portion. They also brought in extensive landfill to round and shape The Loop's lower portion. In the wide, graceful curve of the switchback, they constructed a parking lot for tourists to view Heavens Peak and Packers Roost. Masonry guard walls were built of stone rubble to define the boundaries of The Loop and the parking area, and to add artistic character to this scenic mountain switchback.

Along the Garden Wall

Building the Going-to-the-Sun Road along the steep face of the Garden Wall presented a multitude of problems to overcome. Just getting men in to where they could work was a daily strenuous and hazardous task. On some sections along the Garden Wall, station gangs could hike to their job sites on narrow trails. On other sections, the men had to be lowered over the faces of the cliffs on ropes fastened to trees on the hillside above to get to where they worked. One

of these sections was along Crystal Point (named for the iron pyrite crystals embedded in the red quartzite rock wall) between The Loop and Granite Creek, now Alder Creek. The men, their lunches, and any equipment they had to bring in each morning were lowered in belays down to the job site.

Station gangs worked at several different places along the Garden Wall at once. They worked in both directions to connect one portion of the road with the other. As the work progressed and more sections were joined, getting to job sites naturally got easier.

In order to even get footing at some of the job sites on the face of the Garden Wall, the blasting crews, known as powder monkeys, had to hang on to ropes while they cut a narrow waling ledge along the vertical wall. Then, wearing wool socks over their hobnailed shoes to avoid throwing sparks, they edged their way along the ledge, drilling holes and packing them with black powder and dynamite to blast a bench into the mountainside. One such place was about a mile past The Loop, a place that was known to the road crews as the site of "The Big Shoot."

The NPS limited the contractor to a series of small dynamite charges rather than large single blasts to protect the landscape from excessive damage dur-

ing construction. But Douglas slipped a few big blasts by them. "The Big Shoot" was the largest dynamite blast made on the road.

Opalka, who watched the blast from Camp 5, had spent the three previous weeks packing in 500 kegs of black powder and 80 crates of dynamite to the blasting crew. He described the blast in his interview with the NPS in 1990. The boss of the blasting crew wanted to "shoot it" about 11:30 A.M., just before lunch.

Opalka said he rode a horse up near Camp 5, tied the reins to a stump, and watched. The powder monkey hollered, "Fire!" The rock powder went first, and then the black powder. After the boom, there was a 5- or 10-second delay and then a little tremble. Then the whole hillside, Opalka said, "gave a little thud and folded into the canyon. It

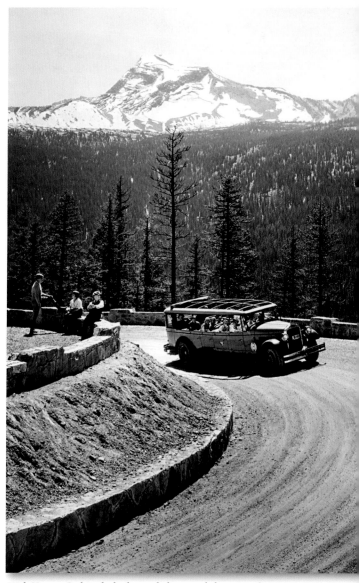

With Heavens Peak in the background, three people lounge on the masonry guard walls at The Loop and a Glacier National Park Transportation bus rounds the bend, loaded with tourists enjoying the scenery. T. J. HILEMAN, PHOTOGRAPHER. COURTESY OF GLACIER NATURAL HISTORY ASSOCIATION.

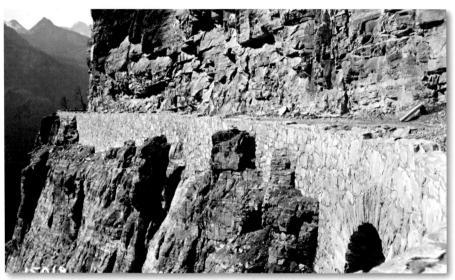

These completed stone rubble retaining walls and guard walls along cliff sections between The Loop and Alder Creek in October 1927 are typical of those used on the entire road. Note the 18-foot span of the rubble masonry culvert. CONSTRUCTION REPORT BY W. G. PETERS. COURTESY OF GLACIER NATIONAL PARK ARCHIVES.

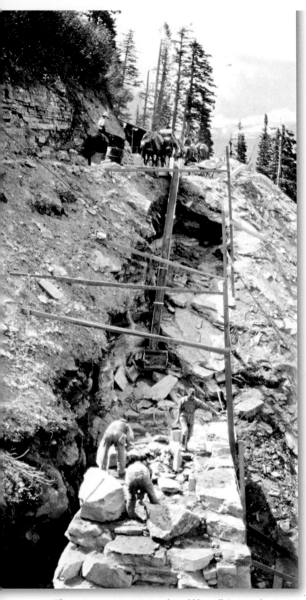

These men are constructing the rubble wall footing along Haystack Butte in July 1927. COURTESY OF GLACIER NATIONAL PARK ARCHIVES.

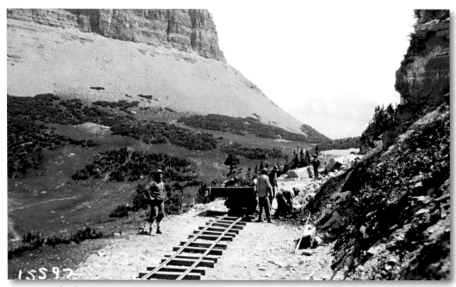

Station men haul excavation rubble using an ore cart on narrow-gauge railroad track. The Garden Wall and trail of the same name are on the left. CONSTRUCTION REPORT BY W. G. PETERS. COURTESY OF GLACIER NATIONAL PARK ARCHIVES.

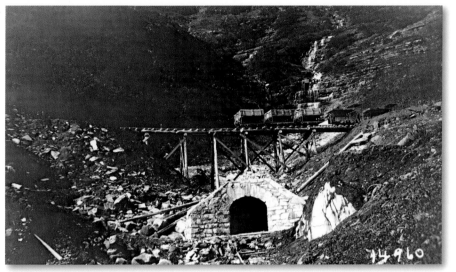

Wall construction on the 6-foot-by-6-foot rubble masonry culvert that was designed to carry the waters of Haystack Creek under the road. Note the temporary trestle and "dinky" engine and carts used to haul fill to work sites. CONSTRUCTION REPORT BY W. G. PETERS. COURTESY OF GLACIER NATIONAL PARK ARCHIVES.

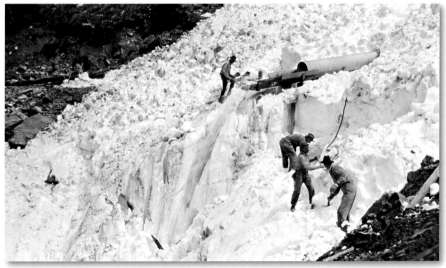

In order to construct two retaining walls, workers shoveled snowbanks 50 feet deep and 40 feet wide from a deep gulch near the site of the Triple Arches. CONSTRUCTION REPORT BY W. G. PETERS. COURTESY OF GLACIER NATIONAL PARK ARCHIVES.

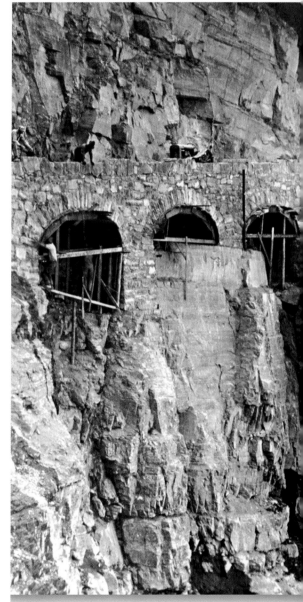

An October 1928 view of the construction of the Triple Arches. COURTESY OF GLACIER NATIONAL PARK ARCHIVES.

was quite a rumble, but not too much noise. You could have drove a truck through it when the blast was done. It was just like a finished roadbed."

On the limestone cliffs west of Oberlin Bend, it was possible to place dynamite and powder charges in the seams of the rocks. On other cliffs, drilling holes to set charges was a slow, cumbersome ordeal. One man held the drilling steel while two men, alternately wielding sledgehammers, pounded the steel into the rock face of the mountain.

Every time the hammer hit, the man holding the steel turned it a little bit. They kept it up until the steel bored a hole deep enough to set the charge. The sound of the hammer blows against the steel was rhythmic, and the effort of the men was mighty.

On the lower sections of the road where they could tow a gas-operated air compressor, the men drilled holes with jackhammers. Douglas, disgusted with the slowness of all the hand work, wanted to get a compressor up to the men working on the difficult sections along the Garden Wall so the men could use jackhammers. One day, he happened to mention this to Opalka and the other men.

While Douglas was in Missoula, Montana, for about two weeks, Opalka figured he and his men could take advantage of a big Sullivan compressor that was not in use.

Opalka figured he could pack it up to Camp 6 in pieces. He asked the mechanic to dismantle it. The mechanic agreed, saying that the only part of the compressor that would be difficult to pack up the mountain was the tank, which was four feet in diameter and weighed more than 300 pounds.

The packers cut two blocks out of a downed cedar tree and tied them onto a sawbuck saddle that was mounted on a big, husky packhorse. They left enough room between the blocks to make a cradle for the tank. Six men lifted the tank onto the saddle and Opalka lashed it down tight with a triple diamond hitch. They hauled the tank and frame up to the top, then reassembled it. They didn't bother bringing the wheels up. Instead, the compressor was placed on skids.

The mechanics and the packers were pretty pleased with themselves. They had the compressor going before Douglas got back. They didn't say a word to him when he returned. They just anxiously waited until Douglas had to make a trip up to Camp 6 at Oberlin Bend and made excuses to accompany him. When Douglas saw the compressor, a broad smile brightened his face. He asked how they got it up there and listened to their tale. "He sure was tickled," Opalka said. "That month we each got an extra twenty-five dollars in our paycheck."

Having the compressor on top helped the blasting go faster. However, relocating the compressor from one site to another was slow, strenuous work, especially in spring when snow was still on the trails. Horses pulled and men shoved the heavy compressors over the mountains whenever they had to be moved.

One of the problems in blasting a bench into a mountain is what to do with the tons of rubble left by the blast. The NPS did not want the rubble cast over the side of the mountain as was done on other Rocky Mountain roads because it would damage the landscape below. Instead, the rubble was used to provide fill and to create native stone retaining walls, or it was crushed into gravel and used for surfacing the road.

In the road's lower sections, power shovels loaded the rubble onto wagons and it was hauled to the crushing plant. In the higher sections, the rubble was taken to the places where stone retaining walls were to be built. When it was not possible to get a power shovel into the blasting sites, the rubble was crow-barred into ore carts and hauled over short sections of narrow-gauge railroad track to nearby dumping sites and moved by wagon teams or trucks to where it was to be

used. There were a few places where the rubble was thrown over the side for one reason or another, which angered Glacier National Park's superintendent Charles Kraebel.

Half-Tunnels

During the excavation along the cliff sections, several rock overhangs, known as half-tunnels, were left for their imposing and natural appearance. These were some of the landscape features Vint and the other landscape architects had designed to enhance the road's appearance. However, the seamed structure of the overhanging rock formations in Glacier made them unstable. These overhanging sections fell into the road below, and by the 1950s, almost all of the half-tunnels had fallen or been removed. The only remaining intact half-tunnel is near Crystal Point.

Pinning the Road

Carving a roadbed out of the steep, sheer face of the Garden Wall formation was tricky enough. But in some places, keeping the precariously placed roadbed from eventually falling away from the mountainside was just as troublesome. That particular problem was solved by pinning the road against the mountainside with retaining walls.

There are several walls shoring up the road along the Garden Wall, but the greatest number of these retaining walls are located in the sheer cliffs of the rim-rock approaching Logan Pass.

Retaining walls are common features in mountain road building. What makes the retaining walls on the Going-to-the-Sun Road unique is the NPS's stipulation that they had to blend in, almost invisibly, with the surrounding landscape. To achieve this, the walls were

constructed of native stone gathered up from the cliff excavations along the road. They were also designed to appear massive, in keeping with the heft of the mountains they pressed against. Stonemasons placed boulders as large as they could handle in most of the walls. In some sections, they used a derrick to place the large, unwieldy stones.

The Russian stonemasons who built the retaining walls were superb craftsmen. They constructed two kinds of

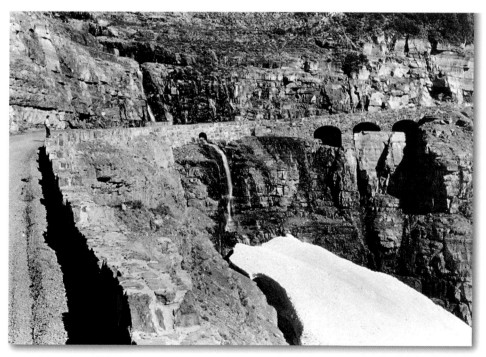

An unidentified man looks east toward the completed Triple Arches and the Going-to-the-Sun Road in 1933. At the left of the picture's center, note the stone culvert that is typical of the stone rubble masonry culverts along the road. COURTESY OF GLACIER NATIONAL PARK ARCHIVES.

retaining walls along the road. Some were mortared and some were dry-stacked. All of the walls were carefully stacked with various-sized, uneven stones to make them appear more natural. Where the road passed over waterways or spanned cliff walls that were too difficult to bench, the stonemasons crafted graceful half-arches to provide outlet portals for culverts and small bridges.

The Triple Arches

While benching the road along the Garden Wall, station gangs came to deep crevices in the mountainsides where high retaining walls needed to be built. Instead of constructing the high, solid retaining walls that would require massive amounts of excavation, arch bridges were designed to span these crevices and join the road together. Russian stonemasons labored long into the night setting the key stones of the arches and shaping rocks with chisels and hammers to form a perfect fit.

Arch bridges, as it turned out, were actually cheaper to build than solid retaining walls. An 18-foot arch with a 6-foot, 9-inch rise and a 10-foot barrel supports a section of the road partway between The Loop and Granite Park Creek. The most noticeable and famous arches are the Triple Arches along the solid rock cliffs of Pollock Mountain. The Triple Arches Bridge is constructed of three 16-foot spans with 5-foot rise arches and an 11-foot barrel length.

Crossing the Waters

The Going-to-the-Sun Road crosses hundreds of waterways. Some of the smaller streams and waterfalls spray and splash their way across the road, but bridges had to be built over most of the flowing waters of the larger streams, or culverts that carried the water under the road. During the nearly 20 years of building the road, eight bridges were constructed. When the contract to construct the west-side road from Logan Creek to Logan Pass was signed in 1925, bridges had been built over the Middle Fork of the Flathead River at Belton (now West Glacier), McDonald Creek, and Avalanche Creek. The Williams and Douglas west-side contract called for bridges to be built over Logan and Haystack creeks. Most of the bridges were constructed of reinforced concrete with native stone abutments. Stonemasons added false arches of native stone rubble to hide the concrete and to replicate the appearance of a masonry arch bridge.

Culverts carry streams underneath the road all along the Going-to-the-Sun Road. Although the culverts are made of corrugated metal pipe, the headwalls are constructed of stone masonry to look more natural and to blend with their surroundings. As with other masonry work along the road, the stones were carefully chosen to be irregular in size and color and appear weathered.

On the westside's lower sections, culverts carry the waters of Sprague, Snyder, Avalanche, and Logan creeks underneath the road. Along the Garden Wall, the waters of Granite and Haystack creeks pour through. The Granite Creek (now known as Alder Creek) culvert is set in the 20-foot-high retaining wall that was required to support the road at this section. On the east side of the Continental Divide, the Siyeh Creek culvert keeps those waters flowing.

Stone Guardians

While crews were constructing the retaining walls and arches necessary to support the roadbed, other stonemasons were building guard walls on the completed sections of road. On the upper sections, stonemasons constructed guard walls along the road to protect motorists from going over steep drop-offs. In the lower elevations, stone guard walls were constructed along the road's border to define the roadway and

add aesthetically pleasing character to the surface of the road.

Native stone, mainly buff limestone and red and green argillite, were used for these walls. The stone was salvaged from excavation operations wherever possible along the road. Mortar sand for the masonry work was taken from a bar in McDonald Creek where a washing and screening plant was installed. Inspectors rigorously examined the masonry work in progress to ensure the completed walls conveyed a sense of irregularity in their courses and as natural a look as possible.

Hard-working craftsmen constructed about eight miles of stone guard walls along the Going-to-the-Sun Road. Generally, the walls are about 18 inches high and 18 inches thick with 6-inch crenellations spaced every 9 to 12 feet.

These guard walls of Glacier National Park, which are both functional and beautiful, became the predominant standard for the guard walls in all national parks.

Finishing Up the West Side

In 1926 a crushing plant was installed near McDonald Creek to crush rock for finishing the roadbed. A drag line was used to bring material to the primary Number-2 Aurora jaw crusher. The rock material to be re-crushed into a fine gravel was handled by a 4½-inch Trailer Gyratory Finishing Crusher, and screening was done by a 30-inch by 12-foot western revolving screen. Power was furnished by a 90-horsepower Russell steam tractor.

Once sections of road were graded, shaped, trenched, and otherwise constructed to specifications, the roadbed was finished with a layer of base gravel and surfaced with two courses of crushed rock or gravel from the McDonald Creek plant. This constituted the surface of the Going-to-the-Sun Road for a long time, but by 1942, all but 10 miles of road were surfaced with either chip seal or pavement.

Construction of the west-side road was completed on October 20, 1928. The tents were taken down, the camp areas were cleaned up, and the crews came off the mountains. The following spring, the road to Logan Pass was opened to an appreciative public on June 15, 1929. Almost 14,000 automobiles traveled the road from West Glacier to Logan Pass that year. Tourists, including park naturalist Morton Elrod, described the road as a series of delights and surprises. ◄

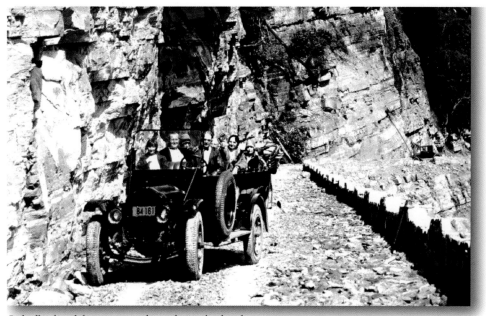

Park officials and their wives tour the nearly completed road. COURTESY OF GLACIER NATIONAL PARK ARCHIVES.

ACROSS THE GREAT DIVIDE

The federal money that was made available to build the Transmountain Highway across the heart of Glacier National Park rode on the wave of the prosperous Roaring Twenties. The west- side portion of the road that was completed in the fall of 1928 and opened to motorists in 1929 ended at Logan Pass. The excitement over completing the road connecting the east and west sides of Glacier was waning in the pall of financial collapse that was slowly creeping over the country when the stock market crashed October 29, 1929. It would be another two years before work on the east-side portion of the road would begin.

There were a series of factors in play in 1929 that delayed the start of the east-side portion of the road and complete the Transmountain Highway. The "Roosevelt Highway," now U.S. Highway 2, which parallels the Great Northern Railway tracks along Glacier National Park's southern border was federally funded in 1926 and would be completed in 1930. It provided motorists a link between the east and west sides of Glacier and reduced the urgency of completing the road through the park during these troubling times.

At the same time, the National Park Service was trying to buy up privately owned properties inside the park boundaries before the Transmountain Highway was completed. Horace Albright, who had replaced Stephen T. Mather as the director of the National Park Service, feared the road's completion would greatly increase the value of the land and landowners would raise their prices. In 1930, the NPS spent $200,000 acquiring private property in Glacier.

Finally, in 1931, Horace Albright, faced with rising property values even

Visitors, automobiles, and red "jammer buses" pack the parking lot at Logan Pass in 1940.
COURTESY OF GLACIER NATIONAL PARK ARCHIVES.

though the road was incomplete and fearful the funding would be withdrawn as the country plunged deeper into depression, recommended the completion of the Transmountain Highway as soon as possible.

The National Park Service opened bids in the spring of 1931 under two separate contracts to speed up construction of the 10½ miles from Logan Pass to the rough-graded road from St. Mary that ended about one mile east of Rising Sun. The contractors were required to complete the road by 1933.

Colonial Building Company of Spokane, Washington, was the low bidder, at $385,366, on the six miles of road from Logan Pass to about one mile past what is now the Jackson Glacier Overlook. The road they were hired to build crossed the Continental Divide and Lunch Creek, rounded the face of Piegan Mountain along Siyeh Bend and traversed the face of Going-to-the-Sun Mountain. Colonial, in turn, subcontracted the lower portion of their section to Archie R. Douglas, who had built the road along the Garden Wall on the west side. Colonial was also charged with constructing parking areas at Logan Pass for motorists.

A. R. Guthrie and Company of Portland, Oregon, was the low bidder, at a little over $200,000, on the remaining four and a half miles from where Colonial's contract stopped to where the road from St. Mary ended past Rising Sun. Guthrie's portion traversed the country along St. Mary Lake past Sunrift Gorge, Dead Horse Point, and part of the Golden Stairs.

A. V. Emery, who had come to Glacier the year before to make the location survey for the east-side road, was the Bureau of Public Roads' project manager assigned to the project.

Logan Pass

At 6,646 feet, Logan Pass is the park's lowest pass across the Continental Divide and provides a stunning panorama of Glacier's shining mountains.

Developing the area around Logan Pass actually did not begin until after most of the cliff work on the east side had been completed in 1932. Until then, Logan Pass was primarily a turnaround for motorists touring the westside road. A "comfort station" for visi-

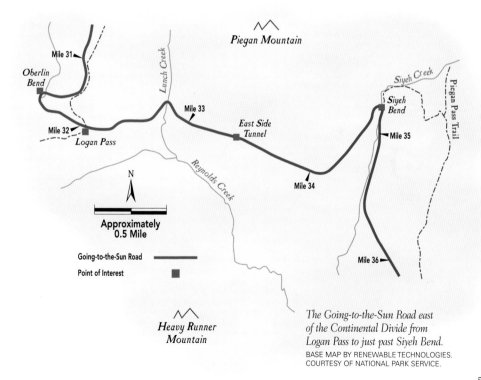

The Going-to-the-Sun Road east of the Continental Divide from Logan Pass to just past Siyeh Bend.
BASE MAP BY RENEWABLE TECHNOLOGIES. COURTESY OF NATIONAL PARK SERVICE.

tors was built in 1931 out of native rock in a rustic design so that the rest-room blended, almost invisibly, into the mountain meadow. When the visitor center at Logan Pass was built in 1967, the stone outhouse was converted into an information center for park naturalists.

When Colonial began constructing the parking areas, they were instructed to do as little grading as possible in order to minimize the impact on the magnificent grasses and flowering meadows of Logan Pass. Thomas Vint, the National Park Service landscape architect whose vision and strong hand are apparent in the design of the Going-to-the-Sun Road, had made it clear that "native soil will be the predominating note in the landscape rather than that of the road surface."

Therefore, the cuts that were made in the ground to shape the parking areas were mostly in rock. Laborers carefully sorted and hauled the waste material from areas that had to be cut away or leveled to areas in the pass that needed fill. Where making cuts was unavoidable, the workmen flattened or rounded the newly created surfaces to conform to the surrounding natural landscapes. Later, the young men in the Civilian Conservation Corps would reseed the disturbed lands with native grasses and flowers.

Log rails and masonry guard walls were constructed to define the parking areas. Along with embedded boulders, the rails and guard walls prevented motorists from driving outside the defined driving and parking areas.

Designed to protect the delicate alpine vegetation, including the annual profusion of spring mountain wildflowers, the parking area at Logan Pass was completed in October 1932. It has been expanded and has undergone changes to accommodate the increase in visitor traffic.

East of the Divide

The road on the east side of the Continental Divide, which provides a view of some of the park's finest scenery, was not as technically difficult to build as the road along the Garden Wall on the west side. However, building it still challenged the best of men. The construction crew had a plethora of difficult situations to overcome on this road, which drops down from Logan Pass to the shores of St. Mary, including

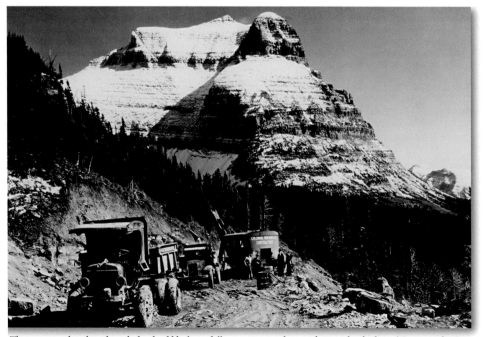

The crew, gas shovel, and trucks haul rubble from cliff excavation on the east slope in the shadow of Going-to-the-Sun Mountain. COURTESY OF GLACIER NATIONAL PARK ARCHIVES.

steep slopes, wicked weather, monstrous snowdrifts, and varied terrain.

All three contractors had a lot to do and a short time to do it. In order to get started as early as possible, Colonial Building Company, the contractor for the road's upper portion, set up a temporary camp at Logan Pass, while a permanent construction camp was being built at Lunch Creek, three-quarters of a mile east. When it was finished three months later, the Lunch Creek camp was set up much like the camps on the west side. Crews put up tents that served as a headquarters, mess hall, supply shack, and sleeping quarters for a 120-man work force. Until the cat skinners could pioneer a road from Logan Pass to Lunch Creek, the only route to the Lunch Creek camp was by trail over Piegan Pass. Equipment, tools, bedding, food, powder, steel, and lumber were brought by crate over the trail by tractors dragging sleds on skids.

A 114-foot-high cliff just east of the divide stood in the way of cutting the road from Logan Pass to Lunch Creek. It was a work stopper! The contractor hauled in a Lima 1½-yard gas shovel to Belton and then towed it, with two 4-yard dump trucks, up the west-side road to Logan Pass. It took three days. The men hooked the shovel to a cable and lowered it over the nearly vertical cliff

face to the talus slide below, risking the safety of the equipment on the main line cable. "Such gambling," said project engineer A. V. Emery in his final report, "is typical of the spirit which saw this road built in less than contract time."

The cat skinner operating the Lima 1½-yard gas shovel bench-cut a road along the slopes of Piegan Mountain for another 1,500 feet, then he had to work the shovel over another cliff to pioneer a road to Lunch Creek. By then, it was September 14, 1931, and winter was about to close in. The shovel was returned to Logan Pass for repairs and a week later was back to help with nearly two weeks of clean-up operations.

The first part of October, crews continued rough excavation eastward, and by October 18, 1931, they had a rough road from Logan Pass to the site of the west portal of the East Side Tunnel. Six days later, they parked the shovel and quit for the winter.

The cat skinners were back on the job the first part of June the next year. After they hiked into the camp at Lunch Creek, they fired up the shovel and began excavating snow, working back toward Logan Pass to open up the roadway cut the previous fall. The construction crew continued clearing snow until the middle of June, when they met up with the Glacier National Park snow

An arrow near the right-hand corner of this survey photo points to the site of the proposed tunnel's east portal. An arrow at top right indicates the staked center line. CONSTRUCTION REPORT BY A. V. EMERY. COURTESY OF GLACIER NATIONAL PARK ARCHIVES.

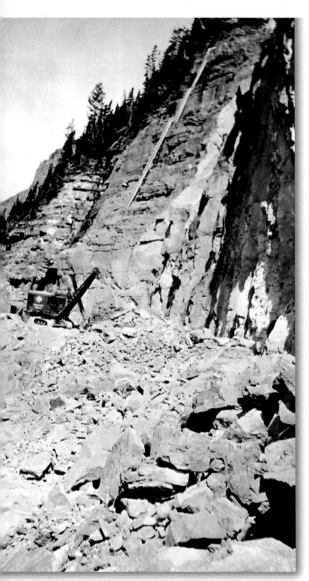

This 1931 photo features the long ladders used in tunnel operations as well as the bench cut to the east of the future tunnel's portal. The rock-cut in the right foreground is 125 feet high from the bench to the top of the slope. COURTESY OF GLACIER NATIONAL PARK ARCHIVES.

shovel a quarter-mile west of Logan Pass. The west-side operator had been making his way to the pass, excavating snow slides and drifts since the first of June.

Before the snow was cleared from Belton to near Oberlin Bend, the Colonial men had to pack in the cook-house supplies over three miles of snow slides to the Lunch Creek camp. By mid-June, however, supplies could be hauled by a truck from Belton, then unloaded one-half mile west of Logan Pass and transferred to a sled. Then a 30-horsepower Caterpillar hauled the provisions across the snowfields of Logan Pass and along the snow cut to the Lunch Creek camp.

While the Colonial equipment operators were cutting road from Logan Pass to Siyeh Bend, Guthrie's men were working to extend the lower sections of the road from Roes Creek over Sunrift Gorge to about halfway between the gorge and what is now the Jackson Glacier Overlook.

Douglas's section, however, which lay between Guthrie's and Colonial's uncompleted sections, had no access for supplies and heavy equipment. His only option was to float the goods in on St. Mary Lake. Douglas had two pontoons built in Seattle and shipped to Glacier

National Park. The pontoons were 10 feet wide, 40 feet long, and had a capacity of 60 tons. They came by rail to the East Glacier station, and then they were trucked the 32 miles to the lower end of St. Mary Lake.

While the pontoons were being built in Seattle, Douglas's men were building a small dock and storehouse on the shores of St. Mary Lake at the mouth of Roes Creek and another at the west end of the lake. When the pontoons arrived, they were slipped into the water at Roes Creek and fastened together to make a barge. Douglas had also purchased a 30-foot gasoline launch to tow the pontoon barge.

As soon as the pontoon barge was ready, the heavy equipment Douglas needed to build his portion of the road was brought in. Two Northwest gas shovels, a 1½-yard capacity and a ¾-yard capacity, were shipped in by train to East Glacier and then trucked to within three miles of the Roes Creek dock. They were unloaded in a wide spot in the road and "walked" the rest of the way to the dock. The shovels then were loaded onto the pontoon barge and towed the four and one-half miles up the lake to the dock.

At this point along St. Mary Lake, the route of the road was 250 feet higher than the dock. When the shov-

els arrived at the dock, Douglas's men winched one of the shovels up to the road right-of-way and used it to pioneer a 1,000-foot tote road from the dock to the road and another two-and-one-half-mile road to Douglas's campsite near the present-day Jackson Glacier Overlook. This tote road was the only supply route used during the construction of the upper sections of the east-side road. Until Guthrie's lower sections of road near Sun Point were passable a year later, a 30-horse-power Caterpillar tractor and trailer hauled materials and supplies from the dock at the lake's west end to the camps along the right-of-way. The rough waters of St. Mary Lake often forced the towing operation to a halt. Launch crews sometimes had to wait two or three days for the lake to calm, which delayed road construction.

The East-Side Tunnel

About two miles east of Logan Pass, a 408-foot tunnel had to be holed out of the steep hillsides before the remainder of the work could progress. This was the most difficult piece of construction on the east side. Before the work on the tunnel could start, a 20-man trail crew had to build a trail 200 feet above the road from Logan Pass to above the tunnel site to bring

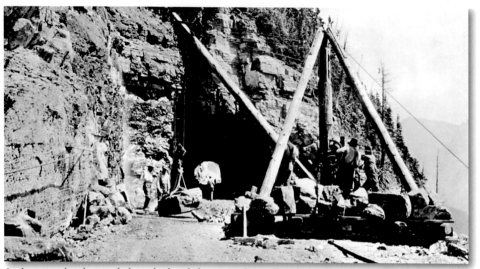

Looking east, this photograph shows the derrick that was used on wall work.
COURTESY OF GLACIER NATIONAL PARK ARCHIVES.

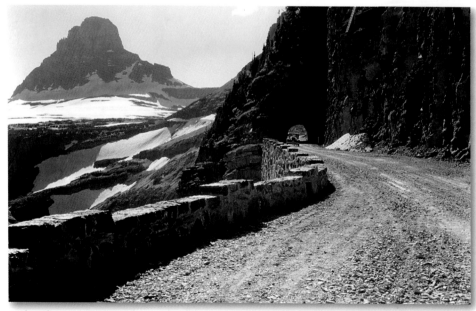

In this July 12, 1933, view of the tunnel and parapet, note the stone retaining wall on the East-Side Tunnel. Mount Clements is the background. GEORGE GRANT, PHOTOGRAPHER. COURTESY OF GLACIER NATIONAL PARK ARCHIVES.

in construction equipment. Crews built a powder house along the three-and-a-half mile trail, and, almost directly above the tunnel site, they constructed a platform to store supplies and house the air compressor that provided the power to operate the jackhammers 200 feet below. Dynamite, compressors, pipeline materials, tools, tracks, ties, ladders, lumber, gasoline and oil for the compressors, coal for the blacksmith forge, drill steel, as well as liners,

bars, and excavating plates were hauled in by tractor or "go-devil" horse teams from Logan Pass to this platform. After unloading the equipment and supplies onto the platform, the men hoisted the necessary supplies onto their shoulders and packed them down a 100-foot drop over a 300-foot switchback trail, then they climbed down another 100 feet on a ladder to a bench that was blasted out of the side of the cliff to create a platform to work on. It took a man, in

good shape, 30 minutes to pack a 50-pound box of dynamite down the cliff to the tunnel site and climb back up to the platform for another load.

The tunnel crews worked on a 24-hour-a-day schedule. Three shifts, 14 men to each crew, made their way down the cliff to the tunnel each day and then climbed back up the cliff at the end of the shift. They bored five feet, four inches every 24 hours. Since shovels or dump trucks could not reach the tunnel site, laborers loaded the debris from the excavation into ore carts and dumped it over the edge.

The men punched through the wall of rock on October 19, 1931, at 10 P.M. Five days later, they completed the final trimming and finish work. The completed tunnel was 408 feet long, 26 feet wide, and 19 feet, 9 inches high. The tunnel had a cave-like interior. In 1942, it was lined with reinforced concrete to prevent water leakages that formed ice stalactites and stalagmites inside the tunnel, creating fissures in the rock and coating the roadbed with thick ice every year.

Stonemasons constructed rubble stone retaining walls on the east and west sides of the tunnel to hold the road in place against the excavated cliffs. A derrick mounted on the road at the portal of the tunnel was used to lift and place the stones in the retaining wall.

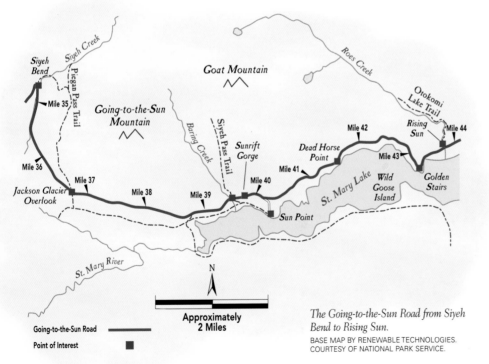

The Going-to-the-Sun Road from Siyeh Bend to Rising Sun.
BASE MAP BY RENEWABLE TECHNOLOGIES.
COURTESY OF NATIONAL PARK SERVICE.

Along St. Mary Lake

THE GOLDEN STAIRS

A. R. Guthrie's contract included the construction of the road along the north shore of St. Mary Lake, a spur road to Sun Point, and the Baring Creek Bridge. As soon as the work season started, he erected a frame tent camp for 75 men and brought in a Marion 1¼-yard, gas-and-electric shovel and other equipment. His crews immediately went to work along the cliffs near the limestone outcroppings known as the Golden Stairs. Heavy cuts were necessary on these cliffs, and a massive stone rubble wall had to be built to support the road. Guthrie's men first had to build a 150-foot temporary trestle so the shovel, trucks, and other equipment could cross over streams and limestone outcroppings to where they were to build the road. This trestle would later serve as a landing and support the derrick for the masonry work. The crews used a power shovel converted to a crane to move the heavy stone rubble rocks in place to build the wall. At 550 feet long and 20 to 30 feet high, the retaining wall at the Golden Stairs above St. Mary Lake is one of the largest and most visible retaining walls along the Going-to-the-Sun Road.

BARING BRIDGE

Guthrie's men and his subcontractors made considerable progress during the 1931 season. In 1932, one of the projects he had to build was a 190-foot rubble stone bridge with a 72-foot arch across the Sunrift Gorge and the rushing waters of Baring Creek. As soon as the excavation and concrete work were finished, stonemasons sheeted the arch with two-inch planking that was bent around the arch. Then they began placing the stones. The stones were supported on an independent ring form, which was twice the thickness of the two-inch sheeting, and rested on stringers and blocking. The stones were four or eight feet in length and were lowered into place by a derrick. The two keystones at the top of the arch were the only stones in the bridge that were tapered or cut.

When stormy weather forced a work shutdown in late October 1932,

Guthrie still had to finish the stone guard walls and curbs for the Baring Creek Bridge and at Sun Point, and he had almost two miles of main line to finish.

All three contractors put forth extraordinary effort in order to complete their projects on time. The six miles from Logan Pass to a mile past the Jackson Glacier Overlook was completed 43 days ahead of schedule. Colonial's section from Logan Pass to where Douglas took over was finished by October 17, 1932.

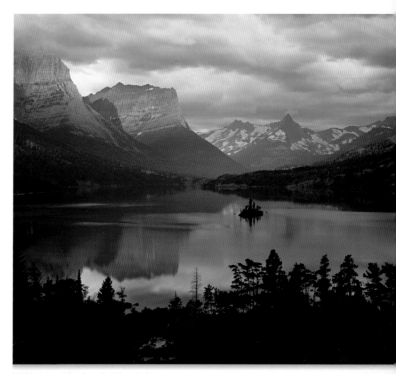

Wild Goose Island in St. Mary Lake. PHOTO BY JOHN REDDY.

Douglas's portion was completed a month earlier on September 3, 1932. Guthrie's four-and-a-half-mile section from where Douglas stopped was not complete, but it was passable.

In late October 1932, the Going-to-the-Sun Road opened to travel from the east and west sides of the park. Work continued the next year, and the remaining work on Guthrie's four and one-half miles was finished in July 1933, just in time for the "official" road opening July 11, 1933, and the dedication ceremonies held on July 15.

The Road to St. Mary

Although the Going-to-the-Sun Road was officially opened and dedicated, the road along the north shore of St. Mary Lake from Rising Sun to the Blackfeet Highway at St. Mary—along Two-Dog Flats and Singleshot Mountain—was narrower than the rest of the road and only rough-graded. It also did not have the stone wall, guard wall, or bridge features that defined the other sections of the road.

During the 1932 work season, the National Park Service and the Bureau of Public Roads designed a project to widen and improve these remaining eight miles to the highway at the town of St. Mary. In some places, the road was to be realigned to take out sharp curves. The project also included the construction of a 42-foot bridge over Roes Creek, a 50-foot bridge over Divide Creek, and a new 140-foot bridge over the St. Mary River crossing, which would be 500 feet downstream from the original bridge. Eight bids were opened in October 1932, and Archie R. Douglas, the contractor who had built the largest section of the Going-to-the-Sun Road, came in with the lowest. The project was not started until the next spring, however, because of winter weather.

Douglas's crews arrived at the work site in June 1933 and set up a 50-man tent camp at Roes Creek. They started drilling operations along the cliffs of the Golden Stairs section to get that portion ready for construction of the masonry retaining wall. In order to complete the cuts and remove the rubble, a Northwest 1¼-yard shovel, three

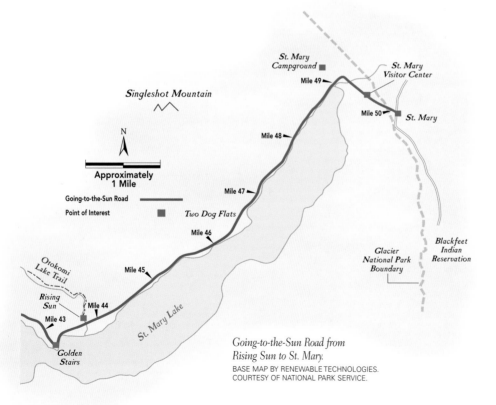

Going-to-the-Sun Road from Rising Sun to St. Mary.
BASE MAP BY RENEWABLE TECHNOLOGIES.
COURTESY OF NATIONAL PARK SERVICE.

Caterpillar 50 tractors, and three 6-yard Athey truss wheel dump trailers were walked the 45 miles from Belton over the Sun Road to the work site. By the end of September, the road at the Golden Stairs had been blasted and cleared and the masonry work was almost finished. The work on the three bridges was also well along and the road along St. Mary Lake had been rough-graded.

Thirty skilled road "finishers" were added to the work force in September, and by mid-October, the finishing work was almost complete except for a few culverts. It would not have taken much more time to complete the project, but a storm hit October 18, 1933, and five days later, the snow was two feet deep. Glacier National Park and the Bureau of Public Roads engineer A. V. Emery ordered Douglas's operation to shut down for the winter.

Ironically, Archie R. Douglas, whose company had built most of the Going-to-the-Sun Road, would not have the pleasure of finishing it. When he pulled his men and equipment out for the winter, his company was bankrupt and his assets were turned over to a bonding company. The final 23 days of work that remained on the Going-to-the-Sun Road was completed in 1934 by the contractor J. G. Edmiston of Kalispell.

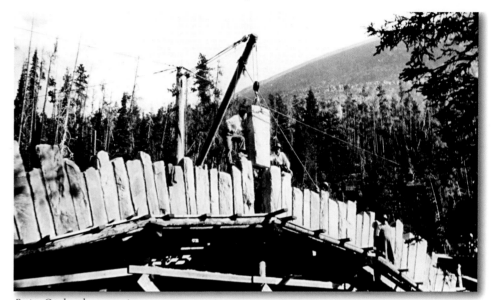

Baring Creek arch construction. COURTESY OF GLACIER NATIONAL PARK ARCHIVES.

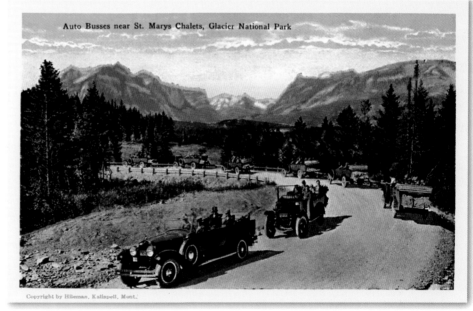

Auto Busses near St. Marys Chalets, Glacier National Park

Copyright by Hileman, Kalispell, Mont.

COURTESY OF THE ROBERT SMITH COLLECTION.

More than a Passing Moment: The Dedication of the Going-to-the-Sun Road

"This is an occasion of much more than [a] passing moment....
The Going-to-the-Sun Highway is a priceless gift to the people of this country and of all nations,
whose citizens come this way to view the scenic wonders it reveals."

—Montana Governor Frank H. Cooney
July 15, 1933, Dedication of the
Going-to-the-Sun Road, Glacier National Park

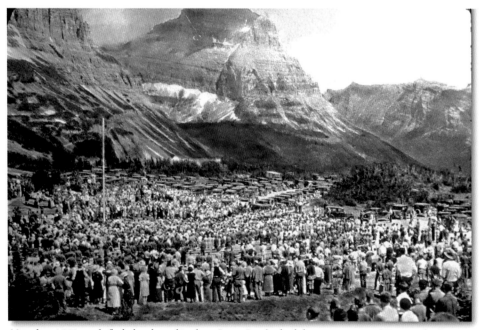

More than 4,000 people flocked to the parking lot at Logan Pass for the dedication ceremony of Going-to-the-Sun Road. COURTESY OF GLACIER NATIONAL PARK ARCHIVES.

Ringed all around by the rugged peaks of Glacier National Park, over 4,000 people gathered at Logan Pass on July 15, 1933, to attend the dedication of the Going-to-the-Sun Road. It was a great occasion, fittingly observed. Canadians and Americans from all walks of life came to the park. Some drove up the road in private automobiles, some came by train and traveled up to the pass in jammer buses. Motor caravans packed with Montanans and visiting dignitaries came from Kalispell west of the mountains and from Great Falls east of the mountains. Several hotels and chalets in the park provided overnight accommodations.

Among the crowd were over 150 Indians from the Blackfeet, Salish, and

Kootenai tribes who had camped at Logan Pass, and hundreds of young Civilian Conservation Corps recruits who had arrived that summer to improve the park's trails and some of the features of the Going-to-the-Sun Road.

The dedication ceremony was organized primarily to celebrate the opening of the road, but it was also to commemorate the first anniversary of the establishment of the Waterton-Glacier International Peace Park, and to honor Stephen T. Mather, the first director of the National Park Service (NPS).

The festivities started with a picnic lunch. Cooks Glenn Montgomery and Ernest Johnson and their helpers used three wood stoves and nine copper-bottomed wash basins to cook batches of chili and prepare hot dogs, buns, and coffee for the expected 2,500 people that would attend. The more than 4,000 people that came were served short portions, but no one seemed to mind. The weather was pleasant, the trip over the road was an adventure, the scenery at Logan Pass was spectacular, and the crowd was buoyant.

The formal ceremonies began with the placing of a memorial plaque honoring Mather for his contribution to all national parks, and for his important role in creating the remarkable Going-to-the-Sun Road for Montana and the

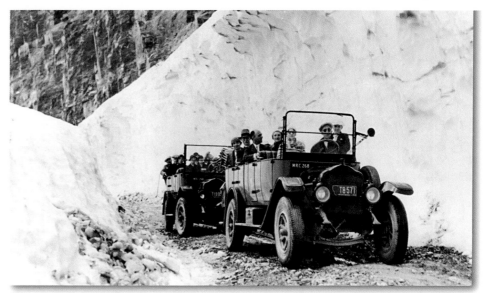

These may be the first tour buses known as "jammers" over Logan Pass on July 15, 1933. The first bus was driven by Aubrey Chapman; the second by Bill Lindsay. T. J. HILEMAN, PHOTOGRAPHER. COURTESY OF GLACIER NATIONAL PARK ARCHIVES.

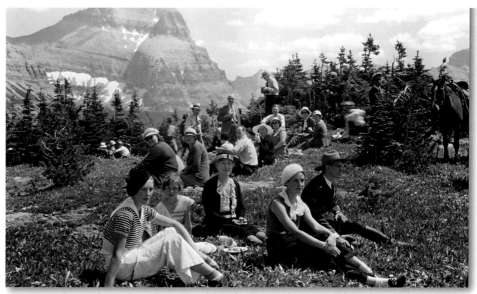

Visitors picnicking on the meadows at Logan Pass during the Going-to-the-Sun Road dedication on July 15, 1933. GEORGE GRANT, PHOTOGRAPHER. COURTESY OF GLACIER NATIONAL PARK ARCHIVES.

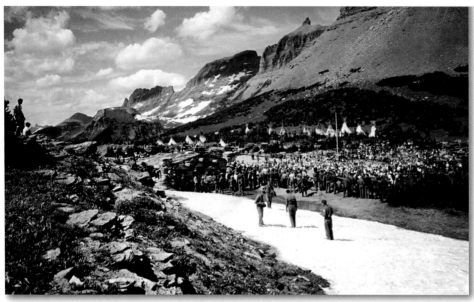

Looking north, a panorama of the Going-to-the-Sun Road dedication ceremonies at Logan Pass. Note the old rock comfort station in the center and tepees in the background. R. E. MARBLE, PHOTOGRAPHER. COURTESY OF GLACIER NATIONAL PARK ARCHIVES.

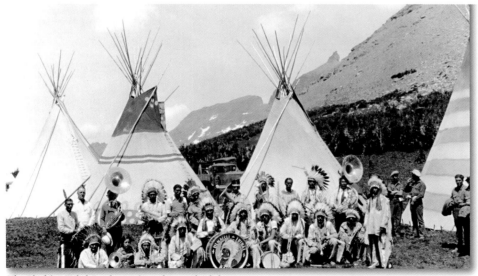

The Blackfeet Tribal Band poses for a photo at the dedication ceremonies. COURTESY OF GLACIER NATIONAL PARK ARCHIVES.

nation. Mather did not live to see the culmination of his efforts. He suffered a paralytic stroke in 1928. The epitaph on the memorial reads: "There will never come an end to the good that he has done."

Horace Albright, who succeeded Mather as the director of the NPS, was not able to attend, but he sent a message of inspiration laced with park policy. Albright's message recalled the early days and his and Mather's plans for Glacier National Park. Most notably, he underscored his and Mather's firm conviction that there should only be a single main road through the national parks. "Going-to-the-Sun Highway fills the need for quick access to high country to see the glory of Glacier's peaks and crags," he wrote. "Parallel roads would add little to the hurrying motorist's enjoyment. It should stand supreme and alone."

And it still does!

Three other dignitaries rounded out the official dedication ceremony. W. A. Buchanan of the Canadian Parliament spoke about Waterton and Glacier National Parks' first year as an International Peace Park. Montana's Senator Burton K. Wheeler discussed the opening of the road. Montana's Governor Frank Cooney spoke long and eloquently. "And now to fill our cup of

joy to overflowing," he said. "We have lived to see the consummation of plans that the federal government has been executing for several years—the completion and dedication of the Going-to-the-Sun Highway. Here we have a highway that is an all Montana road; it begins in Montana and ends in Montana, and we may confidently declare that there is no highway which will give the sightseer, the lover of grandeur of the Creator's handiwork, more thrills, more genuine satisfaction deep down in his being than will a trip over this road."

Between these elegant speeches, the Blackfeet Tribal Band provided music, and a choir recruited from the youthful tenors and baritones of the Civilian Conservation Corps entertained the crowd with a variety of songs.

The grand finale was provided by the Blackfeet, Salish, and Kootenai tribes. The lands of Glacier National Park were once their territorial hunting grounds. The Blackfeet lived on the east side, and the Kootenai on the west side of Glacier. The Salish occasionally came up from the south to sneak past the Blackfeet or Kootenai tribes to hunt in Glacier or passed through the area on their way to other hunting grounds. Although these tribes were enemies,

their animosity toward one another had dimmed over time, but without any formal sharing of the peace pipe. Here at Logan Pass, the tribes gathered to share the pipe of peace. Indian notables who participated in the peace ceremony were Kustata, the chief of the Kootenai Indians, and Two-Guns White Calf, the son of the last great chief of the Blackfeet Nation. Two-Guns is also famous as the Indian featured on the buffalo nickel.

The tribes provided a colorful pageantry to the dedication ceremonies. Dressed in their ceremonial regalia of brightly beaded buckskin, with the chiefs wearing full headdress, they chanted and danced their traditional songs to the ancient beat of drums.

Even as the notes of the last speech were sounded, as the last drumbeat of the tribal peace ceremony was dying on the breeze, and as the dedication of the Going-to-the-Sun Road was cast into history, the road had not really been

completed. Over the next 19 years, more work was done. By 1937, the lower sections of road were improved to meet the Bureau of Public Roads' standards, and in 1952 the crushed stone surface of the road was paved with asphalt.

Nevertheless, this ceremony would forever mark the official opening of this marvel of engineering, this gift to the millions of tourists that travel the Going-to-the-Sun Road every year, this road through the breathtaking mountains of Glacier National Park.

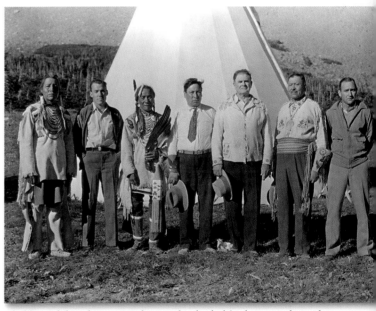

Blackfeet, Salish, and Kootenai Indians—tribes that had fought one another in the past—share the peace pipe during the Going-to-the-Sun Road ceremonies.
GEORGE GRANT, PHOTOGRAPHER. COURTESY OF GLACIER NATIONAL PARK ARCHIVES.

OPENING THE ROAD: A YEARLY CHALLENGE

The deep snows of winter are a continuing reminder that this land, this awesome place, is a remnant of an Ice Age. Its mountains and valleys were expertly carved by receding glacial ice, and it is still the domain of heavy snowfalls, wind-piled snowdrifts, and ground-ripping avalanches. Clearing the snow from this road that dares to cross Glacier's alpine heights is a yearly challenge.

Plowing snow along the steep cliffs of the Garden Wall and past the avalanche chutes is always hazardous. But the most notorious patches of snowplowing hell are along the Rimrock on the west, and along what is respectfully referred to by the snowplowing crews as the "Big Drift" on the east. The Rimrock is a series of nearly vertical cliffs jutting out of the sheer face of the Garden Wall west of Logan Pass just before Oberlin Bend. Snow readily slides off the face of the Garden Wall, piling up on the Rimrock and onto the road in 30- to 50-foot drifts. The "Big Drift" is a quarter mile east of Logan Pass and is the last hurdle before opening the road each year to the public. This wind-blown deposit of snow has grown as deep as 80 feet. To locate the road and clear the snow, a two-person crew uses a "total station" to stake the edge of the road along the deepest portions of the drift. The total station uses electronics and a laser beam to determine the angle and distances to the roadbed based on predetermined readings made during the summer. One crewmember sets up the

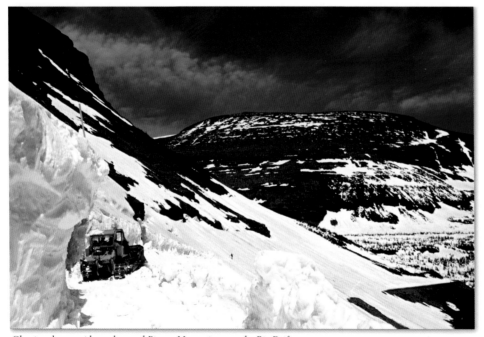

Clearing the east-side road toward Piegan Mountain, near the Big Drift. COURTESY OF GLACIER NATIONAL PARK ARCHIVES.

survey instrument over the control point. The other dons crampons and ventures out onto the icy slopes of the drift with an ice axe and quiver of bright-orange stakes. Using radios to communicate, they place the stakes at 100-foot intervals along the uphill side of the road, then assess the danger posed by the masses of overhanging snow on the ridges above the line. If the danger appears minimal, a bulldozer operator makes a pioneering run (first cut) across the drift. Sometimes the overhanging snow falls as a result of the cut, and the operator pushes that snow off the edge and continues across the drift. If the danger is moderate, an excavator or small explosive charges are used to knock the snow hazard down.

On the other sections of road along the cliffs, bulldozer and tractor operators make an educated guess about where the road is located between cliff and drop-off based on survey points and natural landmarks. The operator makes the pioneering run through the snow, close to the inside wall, then continues making cuts back and forth, with each successive pass cutting down closer to the roadbed.

When the cut is about three or four feet above the road's surface, bulldozers pull out, and the rubber-tired rotary snowplows and front-end loaders move

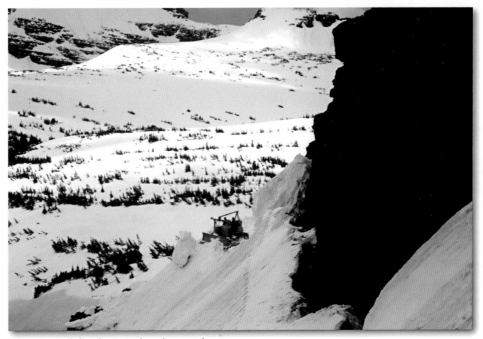

Clearing snow below the Rimrock on the west side. COURTESY OF GLACIER NATIONAL PARK ARCHIVES.

in. The rubber-tired equipment doesn't damage the road surface and the historic stone guard walls as much as the bulldozers and tractors would. Rotary snowplows blow the snowpack off the road, and front-end loaders remove it one bucket at a time. In some places, the final layers of snow are shoveled off by hand.

Avalanches, which are usually filled with rocks and trees, are the greatest danger facing snowplow operators. A close second is going over the edge on "borrowed snow," or snow that has just

been moved and sits deceptively on the outer edge. In 1953, an avalanche above Haystack Creek buried four people, killing two, and scattered the rotary plow down the slope. In 1964, a Caterpillar tractor and the operator went over the edge when the borrowed snow broke out from under the plow. The tractor rolled down the steep hillside below the Big Drift, but both the operator and the machine survived. During the spring 2005 opening, a bulldozer broke through this borrowed snow and slid 600 feet down the slope

Blasting snowdrifts along the Going-to-the-Sun Road in 1932, two and one-half miles west of Logan Pass.
COURTESY OF GLACIER NATIONAL PARK ARCHIVES.

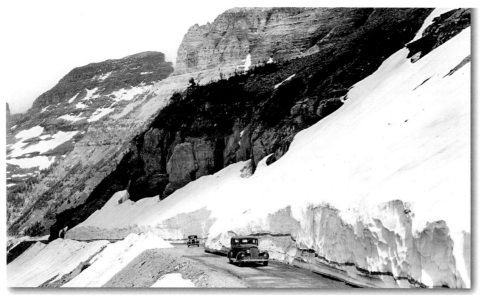

Two cars make their way along the road cut through snowfields along the Garden Wall and Haystack Butte in 1934.
GEORGE GRANT, PHOTOGRAPHER. COURTESY OF GLACIER NATIONAL PARK ARCHIVES.

below the Rimrock. Again, both operator and machine were unscathed.

Most avalanches take place before the crews start to work in the spring, but late snows and avalanches that happen during or after plowing are not uncommon. The safety of the workers depends on the sharp eyes, alert hearing, intuition, and the vigilance of the avalanche lookout. In the 1930s, the lookout typically stayed near the plow and waved an orange flag to warn the operator when there was danger. In the 1950s, the lookout used hand signals or threw snowballs to alert the operator and tell him to back out if an avalanche was approaching. By the late 1960s, the lookout used radios to warn equipment operators about avalanches.

In recent years, road crews in Glacier National Park, with the help of USGS Avalanche Specialists, are better equipped to predict avalanches and determine when it is safe to work and when to pull back and wait. Two or three times a week, specialists ski above the trigger zone to perform tests to determine snow stability and potential for avalanche. Armed with this data, they produce an avalanche forecast that is used by road crews to plan the next step in clearing the road. Even with these advances, avalanche lookouts are still necessary and snowplow

operators still have to "trust their gut" when making decisions.

Avalanches have caused most of the damage to the Going-to-the-Sun Road's prized stone guard walls, but potential damage during spring plowing has always been a concern. As the equipment cuts its way down through the deep snow, the operator does not always know the exact location of the guard walls. Throughout the years, the men have tried different methods to locate the guard walls in the snow. In the 1930s, watchmen walked on top of the snow, probing the drifts with sharp bars to find the guard wall, and warning the bulldozer operators if they got too close. Bulldozers operating below the top of the guard wall were especially prone to hitting them. In 1989, road crews began using front-end loaders to remove the last "lift" of snow along the guard walls instead of using bulldozers. And in some places snow marker poles and brightly painted iron rebar are installed in the fall after the road closes to mark the inside edge of guard and retaining walls.

After the snow is removed from the road and the threat of avalanches is past, rock slides continue to be a problem throughout the season. Every night, rocks tumble down from the cliffs—a combination of gravity, precipitation, and animals scrambling along the rocky slopes. Every morning, crews remove rocks or fallen trees with a snow plow mounted on a pick-up truck. A dozer is stationed in the alpine sections to remove large boulders that sometimes fall onto the road.

Opening the road each spring is a monumental task, requiring gutsy road crews to work in uniquely hazardous conditions. Clearing the snow from the road is not different than in Canada or other western national parks with similar weather conditions. However, Glacier road crews deal with far more avalanche paths. Each year, as they clear the deep snows from the Going-to-the-Sun Road while keeping a watchful eye out for avalanches, they are reminded that despite improved equipment and weather and avalanche prediction, they are still at nature's mercy. ☀

A car drives through the snow cut west of Logan Pass, 1930.
COURTESY OF GLACIER NATIONAL PARK ARCHIVES.

8

A GRAND OLD ROAD

The Going-to-the-Sun Road was laid across the mountains and valleys of Glacier National Park during the 1920s and 1930s. Over the years, it has been the path along which some two million visitors a year have traveled to see the handiwork of ancient glaciers and the home of grizzly bears and mountain goats. The road—with its cave-like tunnels, graceful stone bridges, and guard walls—has endured long cruel winters, heavy snows, and the destructive forces of avalanches, mud and rock slides, and the ever-increasing numbers of automobiles and visitors. Many improvements have been made to the road, and yearly repairs keep it open and safe to drive. The road is a national historic and civil engineering landmark.

The Going-to-the-Sun Road is not only an engineering marvel that takes us through the astonishingly breathtaking scenery of Glacier National Park. It is also a reflection of our past. Building a road through the mountains of Glacier was conceived to satisfy a nation hungry to link the country by roads for automobiles in the same way that railroad tracks linked the country with trains in the nineteenth century. It was built to bring prosperity to the surrounding communities and win public and government support for national parks. The care taken in the design and construction of the road reflected the growing preservation movement that began in 1872 with the creation of the first national park. The road was built at a time when the country was both riding high with prosperity during the 1920s and when it was sinking into the depths of depression in 1929 and into the 1930s. It was the work of a handful of preservation-minded visionaries who stuck to their guns because they believed this nation could meet the demands of growing its economy and building roads designed to preserve nature's work.

Now, more than seven decades after it was finished in 1934, the road is showing signs of its long service in a harsh environment. Along the shores of McDonald and St. Mary lakes, the road is slowly slumping. The fill that props up The Loop is sloughing away, and road crews have had to shore it up. Along the alpine reaches, wear caused by water, the constant hammering of winter weather, and automobiles has taken its toll on the retaining walls that hold up the road. Small trees are growing out of the cracks in the masonry. Cavities are developing in the foot of the walls, and others are crumbling. Avalanches and snowplowing have taken their toll on the stone guard walls. The road has been repaired to keep it safe over the years. But Jack Gordon, a Glacier National Park landscape architect, described one of the fixes to *Missoulian* reporter Michael Jamison in the article "Long Road to Recovery" as an "iron bandaid stapled across the mountain below the Triple Arches, holding up the rock that is holding up the arch that is holding up the road that is holding up the tourists."

In a 1997 study, road engineers and

Glacier National Park and National Park Service officials expressed their concern about deteriorating road conditions, and the Federal Highway Administration verified their concerns. In 2000, Congress passed a bill authorizing the Department of Interior to fund the studies on rehabilitating the Going-to-the-Sun Road. A number of studies culminated in a 10-year plan to make emergency repairs and to reduce the pressures on the road until its rehabilitation could be completed. Glacier National Park and the National Park Service are aggressively seeking funding to maintain and restore this magnificent historic road.

Most of the men who built the road have "gone under," but they left a legacy of their time here: a grand old road that was built to blend in with the spectacular landscape surrounding it, a road that millions have since enjoyed. The challenge in maintaining and restoring the Going-to-the-Sun Road is to preserve the historic achievement of the 1920s and 1930s, while keeping the road intact for future generations to enjoy.

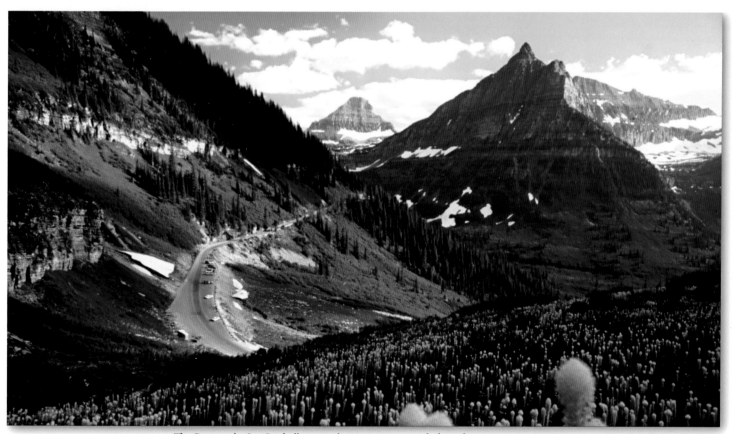

The Going-to-the-Sun Road offers magnificent views as it ascends skyward. PHOTO BY JOHN REDDY.

BIBLIOGRAPHY

Amos, Christine, Mary Shivers Culpin, and Alan S. Newell. *Going-to-the-Sun Road Nomination to the National Register of Historic Places.* National Park Service, Rocky Mountain Region. Denver, Colorado. January 1983.

Begley, Susan, and Ethan Carr. *Going-to-the-Sun Road Nomination as a National Historic Landmark.* National Park Service. Washington D.C. September 5, 1996.

Hufstetler, Mark, Janet Cornish, and Kathryn L. McKay. *Going-to-the-Sun Road, Glacier National Park, Montana, Cultural Landscape Report.* Renewable Technologies, Inc. Butte, Montana. June 2002.

Emery, A. V. *Final Report of Location Survey (1929–1930) of the Transmountain Highway, East Side, Route Number 1, Glacier National Park, State of Montana.* 1930 and Final Construction Reports on Transmountain Highway, various. Glacier National Park Archives. Glacier National Park, Montana. 1931–1933.

Holden, Dennis. "The Challenge: To Build a Highway." *Hungry Horse News.* Columbia Falls, Montana. July 15, 1983.

Jamison, Michael. "Long Road to Recovery, Engineering Marvel." *Missoulian.* Missoula, Montana. July 29, 2001.

Kittredge, Frank A. *Transmountain Highway, Glacier National Park.* Report to the National Park Service. Glacier National Park, Montana. February 5, 1925.

Loeffler, Don. Unpublished Memoirs of Glacier National Park. Various, 2005. Author collection.

Peters, W. G. *Final Construction Reports on Transmountain Highway,* West Side Project #287. Glacier National Park Archives. Glacier National Park, Montana. 1928.

ABOUT THE AUTHOR

C. W. Guthrie is a freelance writer who lives in the Ninemile Valley west of Missoula, Montana, with her husband, retired test-pilot Joe Guthrie. She loves the mountains, valleys, and history of Glacier National Park. This is her fourth book on the park.

INDEX

Page numbers for photographs are in italics, and those for maps are in bold.